Home
Sweet
Maison

DEY ST.

An Imprint of WILLIAM MORROW

HOME
SWEET
MAISON

The French Art of Making a Home

DANIELLE
POSTEL-VINAY

HarperCollins books may be purchased for educational, business, or sales promotional use. For information, please e-mail the Special Markets Department at SPsales@harpercollins.com.

FIRST EDITION

Designed by Suet Yee Chong

Library of Congress Cataloging-in-Publication Data has been applied for.

ISBN 978-0-06-274169-1

18 19 20 21 22 LSC 10 9 8 7 6 5 4 3 2 1

For our home is our corner of the world . . . it is our first universe, a real cosmos in every sense of the word.

—GASTON BACHELARD, *THE POETICS OF SPACE*

Contents

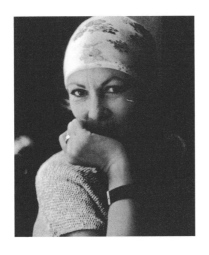

In memory of Jacqueline Manon
(1939–2004)

and

For my French family and friends,
who opened their homes and shared their secrets

Note to the Reader

When I tell people that I love France, I am met with strong reactions. I'm told the French are arrogant, they are elitist, and they look down their noses at anyone who is not French. I was once speaking with an American woman who told me she had never been to France but had heard that they were all snobs, so she wasn't planning to visit. The French snob. It's a stereotype we've all heard before, but that doesn't necessarily mean it is true. When I tried to explain to this woman that the French people I've known have been extremely warm and welcoming, and that cultural differences and misperceptions were at fault, she didn't believe me. She chose to close herself off from learning more about the French because of a stereotype.

The other, equally distorted, reaction to France is the over-the-top swoon. There are those who believe that everything the French do is classy, romantic, and beautiful. And while I agree that French culture is pretty wonderful, the French are definitely not perfect. I love my French husband and his family, but they have all the human flaws of any other family. It's easy to fall victim to a gross idealization of the French. We might think the French are perfect, that their food and fashion are superior to our own, and that we will be *truly happy* if we move to Paris and live our lives in the midst of that old and noble civilization. But in the end, this is an illusion. We can learn a lot from the French, and we can make our lives better by understanding and adopting French culture, but France isn't a utopia.

Both extremes—the French as romantic, fashionable, cultured, oversexed gourmands who live a life of nonstop pleasure, or the French as nasty, arrogant jerks who sneer at everyone—are wrong. The French have good qualities and bad, like Americans or Italians or Japanese or Chinese or anyone else. We must look

thoughtfully and analytically at these traits, so we can appreciate what is superior and ignore what is not.

In that spirit, I aim to share with you the secrets of how the French live in their homes. That doesn't involve becoming French, or even learning French and moving to France to experience French culture firsthand, although I would definitely recommend that you visit. It doesn't even mean understanding all of the (profound) differences between French culture and the way the rest of the world lives. It simply requires that you take a hard look at your home and make some systemic changes. Take what you like and reject what you don't until you create a French-influenced home that is perfect for you.

I'd like to say up front that I am not a "home expert." I am not a trained architect, an interior decorator, or even a full-time homemaker. The totality of my experience in the area of creating a home stems from my own life—here in the United States and in France. Life with my French husband, and my French in-laws, has involved relearning how to do things, and that has taught

me to see the beauty and effectiveness of how the French inhabit their private spaces. My hope is that by reading this book, you will recognize the benefits as well, and be inspired to incorporate the French art of making a home into your life.

My Introduction
to French Homes

The first time I encountered a French home was in
the United States.

I'd been invited to dinner by a woman named Jacqueline Manon, the owner of an antique shop on the main
street of my midwestern hometown. I was seventeen, a
junior in high school, and had applied for a part-time job
at her store, Manon's, hoping to make some money so I
could move into my first apartment after I graduated. I
was taking my first steps toward living on my own, and
fate had brought me to Jacqueline.

She didn't hire me—she was a one-woman operation—
but she didn't turn me away, either. I spent many after-

noons in her antique shop, where we sat in overstuffed chairs talking, drinking coffee, and smoking cigarettes, Benson & Hedges in a black enamel cigarette holder for her, and American Spirits for me. During those afternoons at Manon's she taught me about her business—the buying and selling of precious objects—as well as about her life. I learned about antique furniture and old jewelry and vintage clothes. I learned not only how one could experience culture through these old things, but also how they had the power to lead one to the future.

Jacqueline and I slowly created an unlikely friendship: I was a bookish girl in need of guidance. She was fifty-four years old, the daughter of a French mother and a German father, an ex-model turned hippie who was fierce in her tastes and protective of her privacy. She had immigrated to the United States in the 1960s, thirty-five years before, moving first to New York City, then San Francisco, and eventually settling in the Midwest. It was here, in the middle of America, that she became my first mentor in the art of living.

I arrived for dinner at her home one April evening, climbed the steps, and rang the bell. It had taken

months before Jacqueline had invited me to her home, a large Victorian painted lady overlooking a park. For her, home was a sanctuary, a place she went to escape the rest of the world. Her two Yorkshire terriers, Coco and Chantilly, were barking like crazy, their voices high and sharp over the sound of Edith Piaf playing on a stereo. The door opened, and there stood Jacqueline, wearing a patterned scarf tied over her gray hair, long silver earrings, and a hand-knit sweater.

"Come in," she said, holding the dogs back. "Don't mind my girls, they're very protective of me. Come in, come in, make yourself at home."

We walked through the entryway and into a house unlike anything I had ever seen. Every room—from the entryway to the *salon* to the reading nook to the dining room—felt foreign yet intimate. The house was filled with furniture and objects, plants and books and statues, and yet it felt spacious and elegant. There was nothing minimal or severe about Jacqueline's house. In fact, the very idea of minimalism—that heartless discarding of the past—was the opposite of what I found there. The rooms were formal yet bohemian, orderly yet casual,

with oil paintings on the walls and Joni Mitchell albums stacked on the couch. The air smelled clean, fresh, and yet there was dust on her old books and the silk of a spiderweb in the corner of a window. Her house, it seemed to me, was not just a place where she ate and slept, but also a vessel for her vision of life.

Jacqueline led me to the fireplace, where a crackling fire cast a glow over a small marble-topped table and two chairs. The table was round and beautifully arranged, but clearly had been carried over for the occasion, a little like setting up a folding tray before the television. As I looked around, I realized that there was no television, or at least not one I could see. When I was growing up, the television was the main attraction of our living room, the literal and symbolic center of family life. Here, it was the fireplace that brought us together.

"Take a seat," she said, gesturing to a chair. "I thought we could eat by the fire."

I sat down and looked around the room, noticing a dish of small ammonite fossils excavated in Germany, a jade Buddha she'd bought on San Francisco's Haight Street, and a lacquered box full of Tarot cards, objects

that, I would only later understand, told the story of who she was and where she had been.

Within seconds, Jacqueline returned, carrying a huge platter of grilled asparagus. "Today," she said, setting the steaming platter on the table, "is a very big day. The first asparagus of the season arrived at the farmers' market!"

She sat across from me, unfolded a cloth napkin, and spread it in her lap. Then, although the table was properly set—there were crystal water glasses, bone china, and heavy silver cutlery—she picked up a spear of asparagus with her fingers, dipped it into a pot of aioli, and ate it.

"This is my spring ritual," she said, her fingers dripping with aioli. "Every year, when the first of the asparagus arrives, I eat it by the fireplace with a friend."

I picked up the fork sitting to my left, but she stopped me. "No, no! You have to eat them with your fingers! They taste much better that way." She picked up another spear and bit off the head. "You can only really taste it, spring asparagus, if you eat like Rousseau's noble savage."

I looked down at the asparagus and back at Jacqueline. Eat with my fingers? Really? She urged me to go ahead, and so I picked one up and took a bite.

Although I had never heard of Rousseau's noble savage, and didn't know a thing about French culture, Jacqueline was saying something that gets to the very heart of the French way of seeing the world: set the table formally, adhere to all the conventions of ritual and tradition, then take pleasure in going a little wild.

We spent the whole evening by the fire, eating asparagus dipped in aioli and warm baguette with butter, talking and laughing as the chill outside shrunk away into the darkness. It was a beautiful moment, a particularly French moment, one that was only possible because of the environment Jacqueline had created. The veneration of ritual, a reverence for nature, and a space that had a clear and uniform function—these elements came together to create a magical experience. Jacqueline had invited me into her foreign and special world, her French world, and I never wanted to leave.

Although I didn't know it then, Jacqueline had drawn upon a deeply French aesthetic when creating

her home. F. Scott Fitzgerald said that the rich are different than you and me. So, too, the French. Jacqueline once told me that the French find pleasure in daily life in a way that other people don't, and that she had spent much of her life perfecting that art. She found the American home as strange and exotic as I initially found hers. I came to see that she carried her culture and heritage along with her—the sheer amount of stuff she owned was incredible, from a full set of English silver to a cabinet of crystal glassware—like a snail hauling around a sometimes heavy, but always beautiful, shell. She didn't actually need to be in France to live like the French. She created a French way of life in the middle of the Midwest.

After meeting Jacqueline, understanding the ways of a French home became something of a quest: What was it about the way the French live that is so elegant, seductive, and warm? I began to study French culture and eventually moved to France, where I looked deeper into the question of what made the French home different from any other kind of dwelling. When I married a Frenchman some years later, and was brought into the

daily life of the natives, I saw that French homes were as foreign to me as an igloo or a teepee. Yet I wanted to understand them, to work out the puzzle of the *salle à manger*, to feel at home in the *salon*, to share the *cuisine* with my mother-in-law. I began to see that French living spaces are more than just a collection of rooms. They bring together all the elements that attracted me to Jacqueline's home: beauty, tradition, love, and friendship— these underlying forces can be found in every corner of the French *maison*. Most important, there is a connection between the room and its essential purpose. Each space has its own particular *raison d'être*, a reason for being that no other room has. Living in accordance with the function and purpose of each room creates a harmonious environment.

The French are educated to be logical, formal, and systematic creatures. Following a long and noble intellectual system that values classification, description, and organization over improvisation, creativity, and originality, theirs is a culture of strictly defined codes, worked deep into the fabric of life, influencing everything from food preparation to fashion. These

may explain why the French are notoriously conservative when it comes to the art of living. Their entire culture revolves around consistent ritualized practices. At the same time, the French are tribal, communal creatures who find great pleasure and satisfaction in sharing experiences—both positive and negative—within a group, usually the family. Sharing meals, sharing workloads, sharing expenses for health care and university costs—there is a high premium placed on community and communal life.

It is this Cartesian worldview, mixed with the French love of communal life, that overwhelmingly defines the French home: every room has a particular function, one that creates a pattern for the home that is understood by the group, and allows for fully realized family moments. Of course, there are French homes that deviate from the norms, but these are playful aberrations. The French understand the rules before they break them. Every French living space is an expression of French culture and, consciously or unconsciously, follows certain rituals and rules. From city apartments in Paris to country houses in Brittany, to ancient structures in the

Languedoc, to prefab houses in Provence, these qualities are evident in all the homes I've visited in France. The result? Beauty, calm, purpose, sensuality, and order. After living in a French home, and experiencing the pleasures of the French way of life, I was forever changed.

1

L'Entrée

The houses of my childhood were uniformly modern—built in the 1970s or later—and streamlined for maximum livability. The floor plan was open, with one room giving directly to another room in a way that created an uninterrupted flow of sound, light, movement, and décor. Windows and sliding glass doors abounded, so that light filtered over every nook and cranny, exposing dust, fingerprints, stains on the carpet, cobwebs. But what was most striking about the homes

of my midwestern American childhood was the efficiency of the layout: when you came over to my house, you walked into the middle of the action, whether that meant coming into the kitchen from the garage (as friends did) or through the more formal main entrance, a vestibule with a coat closet on one side and a doormat to clean your shoes, that emptied into the living room.

Our entrance was a byway to other things, a small, empty space unencumbered by obstacles. The floor was tile, so that you wouldn't stain the carpet with dirty shoes, and the only object that might cause pause was the doormat, which required you to wipe the soles of your shoes. The entrance was a transit point, a passage. There was nothing at all to look at or to *do* there, and why should there be? The whole point of coming over was to get to the center of activity—the living room or the kitchen/dining room—as quickly and efficiently as possible. I assumed that a home should always be that way—airy, open, tidy, and above all, functional. Of course, I wasn't aware of my assumptions. I simply believed that everyone lived the way I did.

And then I was invited to a French home.

I went to dinner at Jacqueline Manon's again, some weeks after our asparagus feast. As I stood in the entrance of her home, I looked around, to get my bearings. On my first visit, I hadn't taken a moment to look at the entrance. But now, as I stepped in from the blistering heat into the cool shadows of the *entrée*, it seemed that the space had been designed to slow me down, to demand that I stop and look.

As I stood in the entry, a box of summer berries in my hand as a gift, my eye moved over the space. The entrance of Jacqueline's home wasn't enormous. In fact, it was somewhat cramped, and my first sensation was that I was entering a shelter, one that would protect me from whatever I'd left outside. There were no windows, and a small lamp glowed on a table, filling the space with weak, indirect light. The musky smell of incense hung in the air and swirled over the parquet floor. I would later learn that Jacqueline burned this incense throughout her home in an effort to create a sensory experience for all who spent time there. But it was particularly strong in the entrance, as if this was the way she wanted to introduce her guests to the personality of her home, which

was, I came to understand, *her personality*. The entrance is where that education began.

Near the door stood an oak coatrack, and there was a small bench, where I could sit to remove my shoes. Opposite me, at the far side of the entrance, sat an antique wood credenza with two sliding doors. This, I would later learn, was filled with Jacqueline's signature head scarves, hundreds of squares of printed cotton, ironed and stacked in piles. Up on top of this cabinet, there was a vase filled with flowers, a plastic mannequin head with a cloche hat from the 1920s pulled low over the eyes, an art glass ashtray, and a structured crocodile purse from the 1950s.

Instead of moving directly into the house, as the entryway of my childhood home had, the passage was blocked by a closed door. Through a large glass panel, I could see a sitting room—and I could hear her Yorkshire terriers, Coco and Chantilly, barking like crazy on the other side—but there was a clear separation between the entrance and the rest of the house. This created a capsule in which I stood alone with Jacqueline, host and guest in an orchestrated intimacy. The structure of the entrance

forced me to pause, catch my breath, acknowledge my host, and adjust to the personality of her home, which is to say, *her.*

In fact, this entrance could belong to no one else but Jacqueline. It was *her entrée,* an intricate work of self-expression, one that did not simply act as a way station to the living room, but as a place to announce who she was, where she had been, and what she would share with you. There was no question in my mind, as I stood inside the first space of her home, that I was encountering a unique individual, someone with clear and particular tastes, who was offering these gifts to me, her guest.

I looked to my left and found a curved stairwell that swept up to the second floor. My eye followed the stairwell, ascending with a series of framed etchings that hung at intervals on the wall, eight or so images of gray, ghostly figures staring from the pictures, their cheeks hollow. There were other pictures on the wall—I remember a charcoal drawing of Jacqueline sitting in her store—and still more framed paintings near the coatrack and the lamp, but these etchings were strangely haunting, difficult to look away from.

Many years later Jacqueline would explain that these etchings were images of children liberated from concentration camps after the Second World War. At the time, I was riveted by the pictures but didn't understood how Jacqueline's personal history reflected them—the spinal deformation she suffered from malnutrition, the incessant fear she had of going hungry, the nightmares, and all the other repercussions of her traumatic childhood. Jacqueline's parents had left her in a Catholic convent outside of Munich during the war, thinking she would be safer there than in France. She was very young, three or four years old, and nearly starved to death during the war. Her first memory was of a black American soldier—one of the many Americans in Germany after the war—who came to the convent with food and clothing. He gave her an orange. She had never seen a black man before. Or an orange.

That first day, in the entrance of Jacqueline's house, I knew nothing of the details of her life. We were just getting to know each other and she wouldn't have spoken to me about these things directly. And yet, in her own way, Jacqueline was an open book, ready to share

her life with me. The etchings, the mannequin with the cloche hat, the art glass ashtray, the heavy wooden cabinet filled with her precious head scarves. These objects defined her personality and they created a story about who she was, or perhaps, how she hoped to be seen. The *entrée*, for her, was a physical expression of her identity. It is also, I would one day understand, a characteristic of a French home.

While Jacqueline's *entrée* was a lesson in personal storytelling, she wasn't the type of woman to reveal herself to strangers. It is the same for all of us: we don't tell our deepest darkest secrets when people show up for dinner. We try to make our guests comfortable, which often means removing the reminders of painful events from view. And yet, in some ways, the French home is more personal, and more revealing, than the homes I was used to seeing.

An example that came to mind was the Steiner[*]

[*] Their name has been changed.

home. When I was a child, I spent a lot of time at the Steiner house, a modern two-story split-level with a large yard located just down the road from our place. The Steiners had moved into their house the year I turned eight. They had a daughter my age named Sarah, and we soon became friends. I spent many afternoons at Sarah's, ate dinner with her family, and spent the night on weekends. I learned the rhythms and rules of her house as well as my own. The Steiner family was culturally different from my midwestern family—they were strikingly East Coast in their manners, with different accents, different educational, religious, and family experiences, and with a worldlier perspective than those of us raised along the Mississippi River. And yet their home was remarkably similar to mine.

That is to say, their home was quintessentially American and had characteristics in common with homes in every region of my native country. When one walked inside the Steiner home, there was no indication that this particular family, and this family alone, lived there. Standing in their entrance, I saw no evidence of their personal history at all. You would never know that they

had lived in Maine or loved New York City or had Jewish ancestry. You had no idea that the family business was photography. On the wall near the front door, there hung a stock landscape, the obligatory shoe rack, and a large hanging fern. *They, like most Americans, didn't use personal storytelling to introduce their family culture in the entrance of their home.*

While the French have a reputation for being reserved, even frosty, with strangers, they express themselves quite openly once you get to know them. In fact, my French friends are as warm and friendly as my American friends. The difference lies in the way we Americans express ourselves. When we bring strangers into our homes, we are as open and friendly as can be. We give a tour of the place, taking guests from room to room and actively inviting investigation of our most intimate spaces. We are genuinely hospitable and welcoming, but our homes can often hide our true selves. Whether it be our family history, our political leanings, our religious beliefs, or our unrealized passions—we often mask what really defines us behind stock design elements. We don't display anything that would give too

much intimate information, or make us too vulnerable. Often our entrances are a system of defense, stronger than a drawbridge.

In my experience, American entrances are open, clean, and unencumbered by anything that might slow one down. If we choose to personalize the entrance at all—and why would anyone put time and money into a mere stopgap space?—we usually display framed photographs of smiling children or a group photo taken at a cheerful family event: a Christmas gathering or a birthday party or a graduation ceremony. These framed photos are usually placed on a side table so that they catch the eye as you pass. Have you ever wondered why there is always the same kind of photo on display? The happiest portraits? The ones with people standing arm in arm together, smiling? The successes—the college graduation, the wedding anniversary, the promotion—are clearly an important part of life, but they tend to mask the reality of who we are and how we live: our cultural background, our family history, our church, or our profession. When I see these smiling framed portraits in an entrance, I learn very little about the people I'm meeting. They don't

create intimacy. In fact, it's exactly the opposite. It seems to me that these images of family success and happiness are meant to disarm the visitor, to announce: this home is filled with cheerful, honest people who will treat you well. You are welcome here, but our true selves are not up for discussion.

The French *entrée* is a different experience altogether: it presents you with a mystery. The *entrée* is where one gives clues, creates puzzles, tells stories, and entices you to enter into their lives. I've found that the French can be fanatically secretive about their family histories—I've been on cordial terms with certain French couples and knew almost nothing about their personal lives—but when it comes to actual friendships, and inviting a new friend to their home, this isn't the case. In fact, in my experience, the one place that is the most revealing, and where play and fantasy are encouraged, is the entrance. Perhaps this is why it is so rare to receive an invitation to a French home. An invitation into a French home is an invitation into a French person's inner life. It is not extended casually. It is a commitment to create an intimate and deeper relationship. The homeowner's past

and present meet in their living space, and it happens right away, as you step in the front door.

The entrée exposes one's intimate lives through deeply personal, emotionally charged objects that tell a story about who you are, where you came from, and who you want to be.

In other words, the *entrée* of a French home is never simply a passage to another room. It is meant to slow you down, make you linger awhile, gaze at the spine of a book or into the frame of a picture, acclimatize yourself to the universe of the home. The French entrance demands that you take the time to learn something of the lives you will find within. And they do that by representing themselves and their lives through *story*.

This makes the *entrée* the most curated part of a French home. Take, for example, my French in-laws' place. Of the hundreds of French homes I have visited, I am most familiar the Postel-Vinays' home, where I have stayed often with my husband, Hadrien. Their home is as French as a baguette, a spacious fourth-floor apartment in the 7th *arrondissement,* just across from the Eiffel Tower. A classic nineteenth-century Parisian building, there is a concierge apartment on the ground floor, clas-

sic wrought iron crawling over the door, and a winding stairwell with a glossy wooden balustrade. A small, rickety elevator brings you up to the Postel-Vinay apartment, no. 4, where you will find a porcelain umbrella stand and a potted tree in the hallway. Like so many of the Parisian apartment buildings constructed after Georges-Eugène Haussmann's modernization of Paris in the nineteenth century, the home reflects the French way of life: it has a wide *entrée*, many discrete rooms, and windows that look over wide central avenues. But when the front door opens, and you step into the *entrée*, the apartment could belong to no one else.

As with Jacqueline's entrance, the Postel-Vinay *entrée* was designed to feel distinct from the rest of the house. There are many doors opening off the entrance—one to a living room, another to the dining room, and two more to hallways, one leading back to the bedrooms and the other to the kitchen—but these doors are usually closed, forcing one to stop, pause, and look around. You find that you are in a space that is worth the journey to the house. In the *entrée*, you have arrived at your destination.

The Postel-Vinay *entrée* tells the story of their lives. My husband's father is a doctor who has worked in some of the most prestigious hospitals in Paris. My mother-in-law was an ER nurse for twenty years before deciding to use her medical knowledge and love of language to publish a monthly medical journal, which is now distributed throughout Europe. But walking into the entrance of their apartment, I wouldn't need to know the details of their lives to understand something about my in-laws. It is all there, symbolically, in the *entrée*.

The first thing you see as you enter are shelves packed with medical books. There is the *Histoire de la Pensée Médicale en Occident*. There are ten thick, black, leather-bound volumes of a medical dictionary. There are studies of Roman medical practices and illustrated encyclopedias of anatomy. I imagine my father-in-law pulling out one of these books, paging through the medical cases, thinking about a patient. Then there are the medical curiosities that they have collected over the years—a human skull, a collection of eighteenth-century beakers, medieval pharmacy jars, a porcelain head with phrenological markings, a few old micro-

scopes, and countless other small objects—some valuable, some not—on display.

As you step into the entrance, you stop, to take it all in, then linger a moment. There is something the space wants to tell you, and so you look up and down the shelves, reading the rows of objects. It's a story in images. This way of reading a space—the visual objects arranged so as to tell you a hidden story—is like reading the stained glass windows of an old church. Before widely available in print, the Bible was taught visually, in colorful glass panels, each window giving more and more of the larger story. I went to Catholic school, and every morning before school, we sat through mass. I would move my eye from glass window to glass window, trying to figure out the meaning. So, too, with the *entrée: it is a visual story, a way to represent you and your family. Your life in objects.*

While many of the objects in the Postel-Vinay entrance are meant to contextualize their association with, and lifelong dedication to, the medical profession, they chose *romantic, almost fantastical objects.* I noted that they did not choose to put their diplomas and medical

certifications on the wall. They did not hang up lab coats or stethoscopes or even framed copies of their successful medical journal. The point of these items is not to remind you of their status or class or competence, and they aren't proving their qualifications or trying to impress a visitor with the prestigious name of their *alma mater*. They are creating a *fantasy of their lives*, making their work something larger than just a profession: they are creating a narrative. The great contradiction of the French is this: under their logical, Cartesian shell, they are creatures of reverie, fancy, and the delicate iridescence of the imagination. They value the romantic, the metaphorical, and the unspoken. The *entrée* carries all of these intentions—it is intimate and imaginative, offering its stories silently, without bragging or flashiness.

The objects in your *entrée* introduce you as you wish to be seen. But while history and tradition are an overwhelming part of the French mind-set, the *entrée* can also give hints about desires for the future. At the center of the medical books and objects there is a thin cherrywood desk. At the center of this desk sits an old Olympia typewriter. It doesn't work, as far as I know,

and no one has ever used it when I was around. But the typewriter, tucked as it is under the medical books and curiosities, is there for a reason, a playful, inside joke: my father-in-law has long wished to have the leisure to write a book. He would never tell you this over coffee, and it isn't something I came to understand for years. But the Olympia typewriter is a nod to a part of his identity, a wish he hopes to fulfill someday.

In the *entrée*, you pause, take a breath, and the particular scent of the home fills your senses. Musky, earthy, oriental scents or fresh, sweet floral ones—it makes no difference. This is a moment of grace, an instant when you leave the barrage of uncontrolled sensations and enter a new world.

The *entrée* is where home fragrances are most often used in a French home. Like Jacqueline, the Postel-Vinays use scent to add another personal note to the composition of the room. There is no incense burning in their home—I think Jacqueline's love of incense had more to do with her days in 1960s San Francisco than with her French heritage—but there is often the scent of lavender or mimosa or jasmine in the air. There is a

moment, after I walk into their apartment, when I know instinctively that I have entered their domain.

My mother-in-law uses natural room fragrance sprays, which are much less expensive than perfumes but are made of genuine natural ingredients, often—as with the Durance collection of home fragrances—harvested in the perfume capital of France, Grasse. Scented candles are common, but the scent will remain only while burning. There is the famous Lampe Berger, a French scent diffuser that uses a catalytic burner to burn fuel and disperse scent molecules into the air. These lamps are small, elegant, and discreet. For longer-lasting scent, there is the *bouquet parfumé,* an arrangement of sticks dipped into concentrated scent and left to diffuse fragrance over the course of weeks.

HOME FRAGRANCES FOR THE *ENTRÉE*

The French love to fill parts of their home with fragrances that are personal to their own experiences and memories. Find scents for your *entrée* that appeal to your

memories, aspects of your life, a childhood experience, or anything that expresses your particular taste.

* The French use only sprays of natural essences, never chemical sprays from aerosol cans. Look for mimosa, verbena, fig, sweet orange, jasmine, lavender, sandalwood, and patchouli, as they are popular scents in France.

* Scented candles are also popular. Artisanal candles made of beeswax, soy, or paraffin often release subtle, natural scents. You can find these at farmers' markets or, if you're looking for a bit of French luxury, Diptyque candles (available at Diptyque boutiques or department stores such as Nordstrom in the United States) are coveted among many of my French friends. My favorite Diptyque candle is Figuier, which has a warm wood and fruit scent.

* A *bouquet parfumé* (scented bouquet or fragrance reed diffuser). Lampe Berger and Jo Malone make high-end diffusers (and fragrances), but I've found

les bouquets parfumés anywhere from dollar stores to
Pier 1 Imports. The important thing is to find the
right scent.

* Essential oils and fragrances in a vaporizer. The
 Lampe Berger (available on Amazon.com) is one of
 my favorites, but there are many varieties, all with
 vastly different prices. I prefer natural scents that
 are lighter and won't call attention to themselves,
 such Lampe Berger's Summer Rain, Lemon Flower,
 and Fresh Linen, but there are stronger, more
 distinctive scents such as Crème Brulée and Orange
 Cinnamon, with which you can make a distinct
 impression. I've found that nearly everyone, from
 the less affluent to the very wealthy, uses some kind
 of scent in the home. It doesn't matter what kind of
 fragrance you use, so long as it is distinctly *you*.

I lived for years in an old home in the south of France.
The entrance from the street was the lowest point in the
house, cut into the rock of the village, and left a strong
scent of mineral, earth, and moisture. Sometimes, in the

winter months, the scent of mildew seeped through the stone. No matter how often it was cleaned, the scent remained. I realized that I needed a strong scent, something distinctive, natural, yet not overwhelming. And so I used a woody scent from Durance in a *bouquet parfumé.* It sat in a corner of the *entrée* releasing its perfume slowly into the air.

Aside from covering unpleasant odors—which hopefully you don't have in your entrance—a home fragrance can create a strong emotional experience in a room. It not only creates a visceral reaction in the present, but will also tie you sensually to that place, and bring you back there even years after you've left. I will never forget the day, some years after Jacqueline died, when I walked into a shop and inhaled the same incense she had used in her home. I lingered in the shop for half an hour, my heart in my throat as I relived the vivid sensory experience of being with my friend again.

As I climbed to the Parisian apartment of Jean Deleuze I prepared myself to be overwhelmed. A

close friend of my husband's family, Jean is a passionate collector of *stuff*—everything from quartz geodes to marble busts to old books to seashells to taxidermy to an antique piss pot has been arranged on shelves and cabinets throughout the rooms of his apartment. I first visited Jean's apartment years before, and it had made an impression on me as one of the most fantastical places I'd ever seen. From the *entrée* to the *bureau* and the *salon*, Jean's place is filled with his *objets d'art*, collectibles, books, paintings, and medical curiosities, thousands of objects that represent his personal taste, his vision of the world, and the cosmos that is his (as he calls it) outer shell. Jean's place was so different from an American home that I couldn't forget it. And so, I decided to visit Jean to ask him what inspired his home.

"This is my place to shut out the external world and feel that I am in my own universe. My space centers me. When I come here, I can completely relax."

He leaned forward, gesturing to the large bust on the mantel above the fireplace.

"It is incredible. Nobody notices the same things. Look at the fireplace. Last week, a friend came over and

commented on the two ceramic figures on the fireplace. He didn't even see the marble bust, which is much bigger. Why did he notice one thing and not the other? This question fascinates me."

I looked more closely at the figurines. I hadn't noticed them before. Only the marble bust had stood out.

"Although I am showing my guests my inner world when they come to my home, I am also learning about them, their tastes, their ideas. It is an exchange of ideas every time someone comes for dinner. Incidentally," he said, "nothing in my home is expensive. I found all of this at flea markets and antique shops, and so it is only valuable to me, on a personal level. It is more about finding these things and arranging them here than anything else."

As Jean walked me through the other rooms of his home—each one equally packed with objects—he explained that he was inspired by the tradition of *le cabinet de curiosité.* I had a vague impression that such cabinets connected somehow to eccentric collectors, Russian princes, mad scientists, or museums, but had never thought of a *cabinet of curiosities* in relation to a

home. Later I went online and found that the cabinet of curiosities as a concept had become popular during the Renaissance. Such displays were primarily collections of natural history, or scientific objects—geological, anthropological, and medical. Botanists displayed pressed flowers and lepidopterists displayed butterflies. They exhibited the passions of the collector and were considered a microcosm of the world, a sort of memory theater constructed to remind one of the deeply important and beautiful aspects of life.

Memory theater. This phrase struck me as particularly apt when applied to the use of objects in a French *entrée. The entrance is a stage for personal taste, for objects that inspire memories. By placing them in your entrance, you are creating a theatrical performance, a way to project your personal world and dramatize it for the outside world.*

While Jean's apartment is extremely unusual—the average French home is not packed with rooms of exotic objects and treasures—the impulse to express himself through objects is something I've found in many French homes. I thought of Jacqueline's *entrée*, with its etchings and vintage hats, and the Postel-Vinays' entrance, with

the skulls and medical books. While Jean's home was the most outsize of these three French *entrées*, a common idea connected them.

But creating a cabinet of curiosities in your *entrée* poses one danger: clutter. We've all seen knickknack-filled shelves and *tchotchke*-strewn desks that look like junk collections. There is a fine line between keeping a cabinet of curiosities and hoarding piles of trash. You don't want a cluttered *entrée*, but even worse is an empty and sterile one. Meaningful, expressive objects in the *entrée* transcend clutter. *Expressive* is the key word. The objects must be expressive of your vision, or important to you on a personal level. And they must show how you want to project yourself to the world. Jean had meticulously organized and curated his objects, and the result was engaging and wonderful. I left his apartment feeling that I had experienced a thing of beauty.

Although there was much in common between Jacqueline's entrances and those of Jean and my in-laws' the *entrée* doesn't fit into one particular style. I once rented a French apartment in the 12th *arrondissement* through the website Airbnb. It was on the third floor of

a nineteenth-century building with huge casement windows overlooking the Avenue Daumesnil, just down the way from the Opéra Bastille. Of course, I saw pictures of the apartment before I arrived, but it wasn't until I walked through the door, and stood in the *entrée*, that I felt the real Frenchness of the place. The entrance was painted plaster-of-Paris white, neat and assiduously clean, with a small, tasteful chandelier hanging from a floral ceiling medallion. But that was the only typical thing about it. In one corner, there was a large ceramic bulldog wearing a spiked leather collar. On a small wooden table, two identical stuffed bears—both wearing male clothes—sat entwined in an embrace. Next to the bears, there was a glass bowl of wrapped hard candies and a postcard with two naked guys with sombreros over their crotches lying in the sun, the word *Mexico* written over a blue sky. Before I walked into the *entrée*, the owner was a stranger. But once I stood there, experiencing this French home for the first time, the *entrée* gave me much vital information. I knew the owner's style, his humor, and his sexual orientation. I felt that he trusted me enough to reveal himself, which, in turn, made my

experience in his home special. This is the power of the *entrée*: it introduces you, the inhabitant of the home, to everyone who enters. Even if you're not there.

When we moved to New York City, my husband and I lived in a small, modern rental apartment, one that didn't have anything resembling an *entrée*. The door to the apartment opened directly into the heart of the living space. A guest knocked and was immediately standing next to the couch and the dining table. And there was really nothing we could do to change this—the space was created that way.

I've found that one of the biggest challenges in Frenchifying a modern space is that there are few physical divisions between rooms. We tend to multitask in every space, using the entrance as the living room and the living room as an office, and so on.

If you live in a home without a proper entrance, you can *make a symbolic entrée*. This involves creating a personalized space where one pauses after entering the house. My husband and I attempted to construct

some symbolic divisions in our small, open apartment. We made an entrance area by dividing the space with a coatrack, putting a shelf for shoes next to it, and then hanging framed photographs on the wall near the door. The pictures were extremely personal. My husband, who is a filmmaker and talented photographer, took a series of pictures during the Hurricane Sandy blackout. The hurricane hit months after we had moved to New York City, and we were just getting acquainted with our new home. When we described the pictures to someone we had invited over, it inevitably included the story of our move from France to New York, which of course led to how we had met in Paris. The *entrée* opens a door to our experiences, bringing friends closer.

When my husband hung these pictures, it was a totally natural gesture, one that mimicked the *entrées* he had passed through his entire life. For me, an American who didn't have a lifetime of *entrée* experience, it was amazing to see him create an intimate space, one that was personalized and would lend itself to conversation. Although I understood by that point the value of the French *entrée*, I hadn't studied how other people might

react. The differences between French and Americans entering our apartment showed me that there were very strong cultural expectations about what the *entrée* was all about. Our French guests would stop at the photos and ask about them, expecting a story, exchanging anecdotes about their own Hurricane Sandy experiences. The Americans tended to glide right by the photos, head for the living room or kitchen, whichever room was most occupied at the moment, without pause.

When creating your own *entrée*, there are a few guiding principles to keep in mind. First, the entrance is where the personality of your home—meaning *your* personality and the personality of your family—is most clearly articulated. It is the point of connection between outside and inside worlds, where one leaves the random happenings of the street—the rain or wind or snow or relentless sunshine—and steps into the controlled, protected, and intimate sphere of your life.

We've heard the phrase "love at first sight," and of course we all know the importance of a good first impres-

sion. The *entrée* is where this magical moment happens. It is the point of discovery, that weighty space where you learn about the kind of person, or family, you will be meeting. Even more, it is here that the subtle, underlying tone of the house is presented. Family, career, friendship, and taste—all of this is telegraphed in the *entrée*.

First, and most important when creating your *entrée*, is to follow the dictum: *know thyself.* The entrance is a reflection of who you are. It is the story of your life and the story of your family. Where did you come from? Where are you going? Using objects, color, or artwork, you can create a portrait of the dreams you and your family hold. Because the entrance is the most valuable real estate in your home when it comes to defining who you are and making an impression on others, use that precious territory to give the best version of yourself.

Most important, when creating your *entrée*: don't be afraid of being fanciful and imaginative. There is more room here for improvisation and drama than in other parts of a French home, so be expressive. Choose objects that tell the story of your inner life. You know that beautiful painting of flowers you've hung in the entrance to

your house? That's perfect if it represents how much you love gardening, and your passion for roses. If you don't give a fig about flowers, and don't even like to garden, why put a painting of roses in the entrance? To please others? Or to fill up space? Does it remind you of your grandmother's garden, and consequently the memories of the lost emotional connection to your past? Or a lover you once had? Or a longing for tranquility and luxury? If you genuinely find aesthetic pleasure in your picture of roses—for example, you love the texture of the paint and the color of the vase—that's a perfectly good reason to keep it. But understand your motivation for hanging up this painting. Then use that understanding to pull together the rest of your home. Unity, harmony, and order: understanding how these concepts translate from your personal history to the objects in your *entrée* will forever change your home

French *Entrée*

* Your *entrée* should look like no one else's entrance. Use objects to create a map of your tastes, your interests, and your life.

* Choose books, artwork, or objects that tell your *personal story*—objects from your past, present, and even future. Don't be afraid to dream. Use objects that express hopes for your future endeavors, such as my father-in-law's typewriter.

* Create a place for shoes and coats. I love a big, old-fashioned wooden coatrack, which is a staple of many of the French homes, but hooks on a wall, an *armoire*, or a coat closet will also work.

* Choose a case, bookshelf, or cabinet to display your *own memory theater*. This will showcase small curiosities and give your guests a glimpse of the microcosm of your life.

* Place a natural home fragrance, perfume, incense, diffuser, or candle in your entrance that offers a scent to which you have a personal connection.

2

Le Salon

Between the ages of seven and twelve, before I spent most of my free time in my bedroom listening to music, I was a creature of the living room. Our house was a single-story 1970s ranch-style home, long and wide, with a large, high-ceilinged living room right at the center. It was the midpoint of our home, halfway between the bedrooms on one side, and the kitchen and dining room on the other. In true 1970s and 1980s style, there was a gold shag carpet, long green and orange couches,

and a cushiony recliner aimed toward the television, a heavy box of metal mounted to brackets above the fireplace. I would stretch out on the floor and click through the channels with a chunky remote control, sometimes watching TV with my family and sometimes—as during the long empty days of summer vacation—alone. I was comfortable in our living room.

Too comfortable, perhaps. When I got hungry, I would set up a TV tray table and eat in the living room, watching whatever was on TV, utterly hypnotized. Our TV tray tables were not very sturdy—the legs were made of the same hollow aluminum tubes as the handles on my bicycle, and the tray itself was constructed of a flimsy molded plastic. For reasons that are difficult for me to imagine now, I loved eating on a TV tray in front of the television, especially with the rest of my family, all five of us set up with our individual trays watching sitcoms. There was nothing unusual back then about being diverted from the act of eating by whatever program played in front of us. Nor was it unusual to have little to no eye contact with my parents as we ate, let alone a conversation. We were together, but wholly separate,

individual in our experience, a way of being that could be said to define the way many families live with each other.

In my childhood home, the living room was just another place to gather, like a bedroom or the kitchen. But for the French this is the wrong way to see a space. *Each room must have its own unique status* and must be treated as different from every other room. In the hierarchy of a French home, the *salon* has the highest position, a royal status over the other rooms. Why? The *salon* is the realm of conversation, culture, and exchange, experiences that many French people consider to be the most important activities in their lives. It is also the realm of adults, who—in the French household—are the undisputed royalty of the house.

My childhood living room didn't have a defined position over the other rooms in the house. It had no position of privilege. From my perspective, the living room was the kids' domain, a place where I and my brothers and sisters could do as we wished, and where our toys would often be strewn over the floor, our books left on the coffee table, our dirty dishes left on the bookshelf. My parents probably didn't see it that way, but we cer-

tainly had no clear signal that it was *their domain*. When my parents had friends over, they sometimes sat in the living room to talk and have a beer. But they also would drift from the living room to the kitchen, and from the kitchen to the dining room. Throughout the night, they would move among all three rooms. For all intents and purposes, these three rooms of my childhood home were interchangeable.

The structure of our house surely had a lot to do with this problem. The living room flowed into the dining room, which in turn fed directly into the kitchen. As they were all connected, the sound of the television echoed through all these rooms, making whatever was on—the six o'clock news or Saturday cartoons—the audio and visual focal point of the house. The result? There was a lack of focus in each of the three rooms. Wherever one went, there was distraction from the purpose of the room. Many modern homes continue to blur any distinctions among these different rooms. Want to do homework in the kitchen? No problem. Eat in the living room? Get the TV tray. Watch a video in the dining room? Set up a laptop.

When a space performs every function,
it loses its purpose. A room without
a purpose is a joyless room.

The open floor plan only began to gain traction in living spaces in the late nineteenth century, when advances in heating systems allowed Americans to remove walls and create light-filled communal spaces. Frank Lloyd Wright was an early supporter of this style, and American houses have more or less adopted this structure on a mass level since the 1940s. Most, if not all, of the homes I remember from my childhood were open plan homes. I understand why these homes became so popular. Fluid spaces introduced by the open floor plan create a sense of endless freedom and light in your home, the appearance of unity and togetherness. But I wonder if this appearance of togetherness translates to *actual* togetherness? Does a life without bound-

aries bring us pleasure and purpose? It hasn't been my experience. In my childhood home, as well as in other open floor plan homes I've inhabited as an adult, I've often found myself surrounded by many people doing lots of different things in the same space, but each person is as isolated as if alone. Just because people are together in a room doesn't mean they are actually engaging with one another. Without a sense of ritual or togetherness, without a shared purpose in that room, you are alone in the crowd.

In many homes, the imprecise use of space creates an absence of ritual. Over time, each person begins to use the rooms for whatever purpose that person desires, effectively killing the possibility of shared experiences and rituals in the home. The danger you face is that your family will cease to be a group but become a collection of people who live side by side, roommates sharing spaces in a house but not actually experiencing these spaces together. It is the French belief that a breakdown in ritualized daily life leads to a breakdown in relationships. Couples, families, single people who invite friends over regularly, would be happier in their homes if they

were to use each room as the French do: ritualistically and together, with a clear and specific purpose at designated times. Opening everything up and giving multiple rooms the same function undermine the overriding purpose of a room: to create a sense of togetherness and joy.

A room, by creating a collective space with a function we agree upon, creates unity. We feel a sense of purpose and togetherness. Practicing the function of a room regularly leads to ritual. And ritual is the air a French home breathes and what holds a family, and a community, together.

It may seem glib to blame the open floor plan for family problems. It's important to note that it is not the floor plan, *per se,* that creates the problem but the floor plan's fundamental lack in defining each room's *purpose.* When we do not give a *raison d'être* to our living room, it has no definite function. There will be no hierarchy

or formal role in its position in the home. Ritual breaks down and chaos ensues.

Of course there are many, many problems that create isolation, alienation, and discord in families. These issues also appear in French families, who are on an equal footing with Americans when it comes to divorce rates and depression. But ritual has a way of bringing people—even alienated teenagers or friends having an argument or divorced couples—back together, if even for an hour or two. While we can't go back to the way houses were made in the nineteenth century—modern architecture is a part of the contemporary world, one that expresses many of the beautiful and practical developments of our culture—we can bring back the sense of tradition and purpose that a closed floor plan highlighted. We can infuse each room with ritual.

While the purpose of the *entrée* is to introduce the story of your life and the personality of the home to the outside world, the purpose of the *salon* is to bring people together to communicate. The word *salon*

entered the French language in the seventeenth century from the Italian *salone*, and it came to signify more than just a physical space. A *salon* was also an event, an organized gathering of friends and acquaintances in the home of a charming and well-connected hostess who opened her doors to the artists and intellectuals of the day so as to create meaningful exchanges. The point of these gatherings was to foster discussions about art, drama, politics, and the life of the mind. Conversation was the whole point of *salons*, and while there was an element of entertainment, there was an intellectual and moral flavor to these parties: people visited a *salon* to sharpen their wits, engage in debates, and meet interesting people. In short, they went to show off, to communicate, to battle intellectually, to charm, and to seduce.

American sitting rooms and parlors of the nineteenth century were, in many ways, closer to the French concept of the *salon* than are our modern living rooms. In the Midwest of my childhood, there were old ladies who called their living room a "sitting room" or a "parlor." I remember, as a teenager, hearing the grandmother of a friend invite us to come into her sitting room and

thinking: *Sitting room? Sit and do what?* For me, it was pretentious and stuffy to use such an old-fashioned word. But when I looked up the meaning of the words *sitting room* and *parlor* recently, I found that these rooms were really nothing more than the nineteenth-century equivalent of a living room. Though more formally decorated than our casual living rooms, they were still considered the primary focus for family gatherings and located at a central place in the house. Back then, having a traditional parlor was considered a social achievement, distinguishing you from all those homesteaders who lived in just a few rooms.

If a family had the means, they often bought a piano for the parlor, so as to show off the family's musical achievements and to better entertain guests. The primary form of entertainment was auditory—music, conversation, singing, etc. The world *parlor* is derived from the French word *parler*, to speak. An invitation to a sitting room or parlor meant an evening of conversation and engagement, maybe with some music, perhaps with a little alcohol, before moving on to dinner. Sitting and talking together as a group in a defined space, with a fire

crackling and glasses clinking, was an end in itself. The ability to enclose this warm space and separate it from the rest of the house was desirable, which is ironic when you consider that some of the most sought-after homes at present are lofts and houses with huge open spaces wrapped in walls of glass.

In an American parlor, as in a French salon, the most valuable moments were intimate, private, and without external distraction.

Conversation. Nothing but conversation belongs in the *salon*. This may sound odd to those of us who expect that an evening with friends should involve an activity— cooking together, watching a football game, or grilling steaks, for example. But the French prefer to spend time together in direct engagement with one another. When we're in Paris, my husband and I go to his parents' apartment for an *apéro*, or six o'clock drink taken in the *salon*,

a beloved ritual in French culture. *Chez* Postel-Vinay, my husband and I sit with his parents over a glass of wine, talking about what happened in the news, or about our work, or about the family. Politics is a regular topic, as are the books we are reading. The topics shift, depending upon the group. For example, at the Postel-Vinays' *apéro*, we talk about cultural events, family news, and so on. But an *apéro* with friends may be less about culture, less high-minded, more about mutual friends and the gossip at work. At my in-laws', we spend an hour or so in the *salon*, then move on to dinner in another room—the *salle à manger*—or, if we have plans, we go to the *entrée*, put on our coats, and say goodbye. The hour we spent talking brought us closer together, gave us all a sense that we are part of a group. *We achieved the highest purpose of the living room: We shared a moment together.*

The French cherish and nurture this simple daily event. They look forward to this six o'clock ritual as a shared moment of pleasure outside the run-of-the-mill duties of work and family, and they protect it from the onslaught of chores and distractions that could easily displace it. In France, there is as much ambition and pres-

sure to succeed at work as there is in the United States or other economically competitive countries. The idea we have that the French are dreamy layabouts is simply false. There is much talk of the official thirty-five-hour workweek French workers enjoy, and it's true that certain salaried positions and government employees have more time off than we do in the United States. But doctors, small business owners, freelancers, and the self-employed can be sucked into the kind of work schedule ambitious Americans or Japanese keep, putting in sixty-hour workweeks and skipping summer holidays. And yet I've watched French people arrange their schedules—starting work early or working on the weekend—to make sure that there is adequate time for the ritual of *apéritif*.

Our American happy hour, the beloved after-work drinks get-together, is a close cousin to the French *apéro*, but it does not carry the same cultural position, and it is not nearly as uniform as a French *apéritif*. In the States, I will meet friends at a bar for a drink anywhere from 5:00 until 9:00 P.M. Happy hour specials run earlier, but Americans often leave work later and combine an after-work drink with a quick dinner. But the major difference

between the American after-work drink and the French *apéritif* is the location. My American friends tend to frequent bars after work, and while the French love to stop by a café for an *apéro* on their way to dinner, there is a dedicated practice in France of hosting an *apéritif* in the home, especially on weekends. The elaborate ritual of sitting down with friends to share a drink is totally separate from the idea of work. I've never known my French friends to go out with colleagues for an *apéro* after they leave the office, unless there is a genuine sense of friendship between them, one that has nothing to do with the idea of networking. There is also the expectation in France that, after an hour or so, *apéro* time is over and everyone will go on to dinner.

An *apéro* doesn't need to be fancy. Usually it involves a bottle of table wine, a bowl of snacks (potato chips or pistachios), and a few friends. When I lived in France, it was common for people to stop by my place at six or so, and an impromptu *apéro* would ensue. It's a simple ritual that creates a moment of connection between people and adds a distinct pause to the day.

Jacqueline Manon was quintessentially French in

this respect. Her day was divided into ritualized moments, coffee in the morning and an *apéro* in the evening being two of the most important. Every day at exactly six, cocktails were served, a gin and tonic with lime in the summer and a margarita with Rose's lime juice in the winter, made to order by her husband, Lee. I had a standing invitation to join them, and so there were many evenings when I dropped by unannounced. I didn't need to knock. I would walk through the *entrée*, pushing away Coco and Chantilly, and make my way into the living room, where Jacqueline and Lee would be sipping their drinks and cracking pistachios from the shells.

We always sat in the living room for an *apéro* at Jacqueline's house, unless it was a beautiful warm day, when she often moved out to the garden. She didn't have a liquor cabinet or bar in her living room, and so she would carry everything from the kitchen and set it up there. The space was designed for comfort, with plush chairs and a comfortable couch. She would set up the same marble-topped café table that she used each spring to eat asparagus, lay out small bowls of nuts and a stack of paper napkins, and *voilà!*

It is important to note that the six o'clock drink calls for the correct environment; i.e., the *salon*. If you are in the kitchen cooking and drinking with friends, you may be having a good time, but it would lose the structure of the ritual. Instead of having a conversation, you will be swept away in the task of cooking and cleaning up. I have wineglasses, bottles of wine, and a small stock of liquor ready in a cabinet, so that we can sit down in the *salon* without ever having to go to the kitchen.

Recently a friend of mine designed a new kitchen for her beautiful historical home. She tore down the wall between the kitchen and dining room and installed a massive white island that spanned the entire space. The island held an induction stove and storage drawers for pots, pans, silverware, etc. A seating area at the opposite end of the island was equipped with four tall barstools, where guests could relax, talk, and eat. My friend chose this design because she wanted to create a space made for communal cooking and eating. Her guests, she told me, could sit at the island and have a drink or, if they chose, chop vegetables and help cook the meal. After the meal was prepared, they would eat there, at the counter.

This vision of collective drinking, cooking, and eating in one space is the opposite of a French experience. Mixing these activities up may have a homey, casual vibe, but it is also deeply confusing. What is the purpose of the room? Work? Pleasure? Conversation is an art and cooking is an art and eating is an art. For the French, the three are highly ritualized events. How is it possible to do all of these activities well—and more important, find them *pleasurable*—if you're doing them all at the same time? Are you meant to relax at the counter? Or to work? Does the host expect you to chop onions or tell funny stories? Should you have dessert or load the dishwasher? A whole host of confusing questions are thrust on the situation that would be resolved if the *apéro* was simply moved to the living room, where there is nothing at all to do but have a drink and (the real point of the moment) to find pleasure in the art of conversation with friends. Mixing these spaces is confusing to the French. It's a problem of multitasking, choosing efficiency over intimacy and pleasure. And this is something the French would never do.

When entertaining friends, bring them to the living

room before dinner. Make sure that your living room is set up to perform its particular function as a comfortable, welcoming space for human interaction. It is not the place for eating dinner. It is not for setting up the baby's play yard or for the kids' LEGO sets. It isn't the ideal place for a computer workstation. *The salon is a room meant for entertaining guests, for gatherings that involve talking, playing cards, or board games, for entertaining.*

As the *salon* was traditionally (after the *entrée*) the most public room in the house, it was often where people displayed their best furniture, the most impressive art, and all the personal items they hoped to show off. But you don't want to be pretentious, and it is often more interesting and tasteful to keep things simple, and to add interest by placing your favorite furniture, an art book or two, and some elegant decorating touches that define your personal taste and experiences. I lived in Japan for a few years, and so I have a Japanese vase in one corner of the *salon*. My father was a soldier in the Vietnam War, and I have a doll he sent back home sitting under a glass dome on a shelf. We have a stack of hardcover art books on a table, but all of these books were bought from ex-

hibits we went to ourselves, so that we can talk about the art we saw, if we choose. All of these personal objects and pieces of décor are meant to inspire conversation and draw out the ideas and opinions of our guests. Because the function of the *salon* is to find common ground, to communicate, and to entertain.

French kids spend time in the living room like everyone else, but in a French home, it is clear that the *salon* isn't for playing with toys or binge watching Netflix alone in a beanbag chair. That is because the living room is not the domain of children in France. They are guests there, privileged guests, but guests nonetheless. The *salon* is the realm of adults, who are the undisputed royalty of the house.

I've sat in many French living rooms over the years and observed kids as young as six or seven sit with the adults during an *apéro* and join in the conversation. The topic of discussion doesn't matter, but the fact that the kids were there, sitting with the adults, having a glass of juice or sparkling water, sharing the moment,

changed my way of thinking about children's roles in the family. Ten minutes before, the kids would be lounging like American kids in their bedrooms and then, upon entering the living room, their manner would sharpen and they would engage in the world of adult conversation. In France, it isn't unusual for teenagers to have a glass of wine with their parents. I've never seen a French teenager abuse the privilege, perhaps because it would be so out of step with the purpose of the ritual. Children aspire to the *salon*. They changed their behavior to be worthy of the *salon*. The point of the *apéro* is not the alcohol, nor the feeling alcohol produces, but the sense of togetherness: everyone sharing their time and ideas with each other.

Often, when an *apéro* is going well—everyone has had a drink or two, the conversation has become lively, and the evening is too fun to end—it evolves spontaneously into an *apéro-dînatoire*, a light, casual dinner with wine and finger food. Whereas a traditional *apéritif* is comprised of wine and simple snacks, the *apéro-dînatoire* is slightly more complicated. A table is pulled out, much like Jacqueline's marble-topped table, and filled with a

mixture of hot and cold finger foods—country pâté and baguettes, cheese and sliced meats, savory cakes, small pizzas, grilled or fried sardines with lemon. The key word for this ritual is *easy*: Whatever you set out should be whipped up in a minute, easy to make, and easy to serve. I once made the mistake of cooking a full meal for an impromptu *apéro-dînatoire*. I was too long in the kitchen, the food too fussy, and the mood soured by the time I brought out dinner. The magic of the moment had passed. We had left the realm of *apéro-dînatoire* and were left with just plain old dinner.

That brings me back to the television, the *bête noire* of the living room. One of the most disrupting changes in the French *salon* in the past fifty years has been the introduction of this piece of equipment. There are French people who hate it and would never allow it in the living room. Then there are those who embrace it, and have their TV over the fireplace or on a prominent wall. My feeling is that if you want to create the feeling of a French *salon* in your home, it is time to get rid of the television. I am not telling you to throw it away or only read books for entertainment. I love television as

much as anyone. But the TV is at odds with the purpose of your living room. The flashing lights and colors and sounds of the television will throw the room off balance. Even if you've turned it off, the black screen will annihilate your ambiance. That black screen will become a great black hole whose gravity pulls every bit of good energy from the space. At best, it eats the space where something beautiful might live. At worst, it will poison the environment.

The French are keenly aware of the problem this device causes in the home. It goes against everything that they love about their *salon*: it creates quiet viewers rather than active conversation. It creates passive reception of information rather than the active sharing of ideas and news.

When it came time for my husband and me to buy a new television, I found myself in an elaborate, oh-so-French debate about the very idea and purpose of a television. I wanted to watch Netflix and HBO series, but Hadrien was worried that a large television would ruin the calm of our apartment. When I searched for ways to hide the monster, I found articles in French design

magazines that suggest all kinds of creative camouflage. There were suggestions to download a beautiful image and leave it on the screen so that it resembles a painting. I read about placing the TV inside a cabinet and keeping the doors closed, which appears to be what most people do. There was also the idea of constructing an automatic mechanism that lowers the television into a custom-made slot, which looked expensive and difficult. In the end, I went with keeping the television out of our main living space altogether. I opted to hang it in a nook in our bedroom, where, when I'm not watching a show, I play a cozy video of birch logs crackling and burning in a fireplace.

While there are many creative ways to camouflage your television, the best solution is to simply move away from having this technology in the living room altogether. If you can afford it, evolve away from the heavy, boxy hardware of the traditional black set and move on to the highly portable projector, where images are thrown onto fold-up screens, or even your living room wall. Aside from being inclusive—family and friends can sit down to watch a film or television together—it is

the way technology is moving, and it is the rare instance when technology and livability in your home coincide. As a way to save your *salon*, you should welcome it. If you love the experience of watching film on a larger screen, and have the money, buy a projector. I have both American and French friends who have opted to splurge on a projector. One friend projects everything he watches on a white wall in his Manhattan apartment, while the other uses a retractable screen that can be rolled and unrolled. When she's finished watching a show, she folds up the screen and stores it away in a cupboard.

Much of what we think of as fancy French décor—chandeliers, gilded mirrors, ormolu clocks, and so forth—are usually found in the *salon*. There is an iconic look, an archetype of *salon-ness* anyone who has glanced at a French home in a film or magazine would recognize. While the types of décor change from region to region—the Parisian *salon* is going to differ in significant ways from the living room of a Mediterranean home in Nice or a mountain house in the Alps—there are objects that show up in nearly every French living room.

Once, after Hadrien and I moved to New York, his

sister visited us for Christmas. She had never been to New York City before and found many things to be different from Paris. On her second day in the States, she asked her brother: *Where are all the mirrors?* I realized that she had a point. There weren't five opportunities to check your appearance in every room. There weren't glimmering golden-framed pools of reflection above every fireplace. That is not the case in France, where there are mirrors everywhere. In every restaurant, in every home, mirrors upon mirrors upon mirrors. And while I had never seriously thought of the mirror as particularly French, the traditional gilded mirror is perhaps one of the most recognizable French objects, aside from the baguette and the Eiffel Tower. One look at the carved scrolls and acanthus rosettes, at the silvering of the glass, and you know you are standing in a French *salon*.

The question of color, fabric, furniture, and décor for the *salon* is pretty straightforward. The French generally prefer simple colors, high-quality fabrics, antique furniture, and classic French décor in their *salon*s. There is often a hanging light fixture, dual love seats positioned face-to-face in front of the fireplace, and a mirror hanging

over the mantel. There is the glass bell jar with a striking item—a seashell, a stuffed bird, a small clock—on display and the array of oversize hardcover books—art or history or medical books are common, although I've seen *salon*s with vintage hardcover *bandes dessinées*, the French and Belgian comics that are wildly popular, spread out on the coffee table. These are rote cosmetic choices that will look and feel French. After you restructure your living room, you can add these items at will. And while they may have little to say about your personal taste, that's perfectly fine: you already expressed yourself in the *entrée*. It is not urgent that you do so in the *salon*.

The French are not big on taking risks when it comes to home decoration. They are, for the most part, baffled by loud or, as they would say, *eccentric* design choices, and so they tend to stick to traditional colors and styles in most cases. My husband once told me that many of the young French women he knew in college loved traveling to London because they could experiment with their clothes and hair without being ridiculed. The same goes with decorating their homes. They will choose a traditional piece of furniture over a trendy one, a neutral color

over a bright one, and a quiet painting over a loud one. French group-think can be a relentless and unifying force.

And yet the French love contradiction. The living room is a place for entertainment, and thus performance, debate, and theater, and so it is acceptable to go—as Jacqueline did with her asparagus—a little crazy. There is no place to do this better than the living room. The classic French *salon* provides the opportunity to play the provocateur. Bringing in a conceptual object—a strangely shaped avant-garde sofa, a colorful exotic rug, a striking painting, or a sexually alluring photograph— provides an element of theater and can get things rolling when guests arrive. Jacqueline had a sexually charged seminude photograph of herself—taken when she was in her thirties—hanging on a wall in her living room. She watched, amused, when my boyfriend couldn't take his eyes off it. Unusual and striking objects inspire commentary, at least among the French, who are always quick to note instances of broken protocol. This is desirable. It guarantees that you won't bore people, and it gives you a topic to fall back on when you find dull guests parked on your couch.

Before we were married, my husband had an "artistic" coffee table in his studio apartment, a seventh-floor walk-up in the 2nd *arrondissement* that I called his *garçonnière*, or bachelor's pad. The table was constructed out of magazines, the spines of which were pressed together in a whorl, like a tightly clenched flower bud, with a sheet of glass over the top, sealing them. The first time I saw it, I objected to the use of written material as furniture, asserting that magazines should be read, not used to hold a glass of wine. Of course, he objected right back, and said something to the effect that he liked the idea of making words useful. I responded by asking him if he would shred books to make a carpet. And so it went. His funky table had achieved its purpose: we went back and forth, flirting and sparring over his ridiculous table, and were laughing by the end. He had laid a trap and I fell right into it. The French want their guests to react, to feel a need to express themselves, to speak up about ideas and tastes. If that means putting something a little crazy in the *salon*, then so be it.

But not *too* crazy. There are basic decorating rules that must be followed in the living room. First, the color

scheme should be neutral. It is considered bad taste to paint the walls with loud colors. When a French person enters a home with vivid red or yellow walls, or with loud wallpaper and bright curtains, they experience a deep sense of discomfort. It isn't natural to squint to look at a room. Unless you plan to use the color scheme as a topic of conversation, it is better to keep it simple. The walls in your *salon* should be soothing, natural colors—cream, linen, bone, pewter, Parma gray, eggshell blue—and the texture of the emulsion should be chalky or matte, never glossy or reflective. One finish that gives the highly chalky texture of a French wall is found in Farrow & Ball's Estate Emulsion. The point is to keep distractions to a minimum, unless those distractions are planned. Every choice you make should be in service to the purpose of your living room, which is to bring you closer to the people in your life. There is nothing more important about the *salon* than that.

French *Salon*

* A gilded mirror will add brilliance and light to your *salon* (or any other room except, perhaps, the kitchen). Inexpensive reproductions are abundant, and original eighteenth- and nineteenth-century mirrors can also be found online and in antique stores.

* A chandelier.

* Moldings and ceiling medallions. While having original moldings, wainscoting, and trim depend entirely on the age and style of your home, it is possible to add these decorative flourishes without much time or expense. Home Depot and other home improvement stores carry many add-on

varieties or, if you want authentic plaster moldings, you can hire a professional to create the perfect style for you.

* Keep furniture and art traditional, and colors subdued. The best colors for the *salon* are neutral.

* Consider including a provocative or conceptual piece of furniture, artwork, or object in your *salon* to inspire discussion. This can be anything from a picture to a piece of furniture, so long as it provokes conversation.

3

La Salle à Manger

Some of the most clear and universal rules regarding the French home pertain to the *salle à manger*, or French dining room. *Salle* means "room" and *manger* means "to eat." Its function is exactly as the name suggests: *it is the room where we eat*. And eating is no small matter. For my French family, dinnertime is one of the most important rituals of the day, a great moment of connection that brings everyone together to share food and conversation.

It is no surprise that the *salle à manger* is the most beloved, and the most traditional, room in a French home. It carries the weight of French culture and family on its back, thousands of years of accumulated history and culture all in one space. It is the place where all of the unspoken expectations and traditions of their society can be seen in action, and where foreign ideas and practices clash most strongly.

In terms of function, etiquette, and form, there is no more rigidly defined room in a French home than the dining room. That is not to say that the *salle à manger* is formal or stodgy. I've eaten at extremely modern dining tables, and almost every meal I've eaten in France has been comfortable, relaxed, and fun. But underneath every convivial dinner party lurks a loyal adherence to the deeply important function of the dining room, namely, as a protected space to share a meal and reaffirm your connection to your tribe.

The most important characteristic of the French dining room is that it must be physically distinct from the kitchen. The kitchen is a functional space where the meal is prepared. The dining room is where meals are eaten.

Eating together is such a simple idea, but somehow in America it has become rare for family and friends to sit down at home and share a meal together. That is different from eating side by side in the same general area. Indeed, when we're eating and watching a baseball game, or when our kids are playing video games at the table, or when we're eating pizza and talking on the phone, the elemental distinction between entertainment, family life, and dining breaks down. In our modern homes, especially those without a separate dining area, we tend to cook and eat and clean up at the same time. We balance plates on our laps while watching reruns of *Modern Family*. We check our e-mail and eat a sandwich at our desk. It's easy to do. As I'm writing this, I'm drinking coffee and eating a pastry for breakfast in my office. Do I usually eat breakfast with my family in the morning? Sometimes, but not often. Mostly, I grab coffee and go to my office, where I check e-mail and update my social media before I work. Despite being married to a Frenchman, and loving the rituals of French life, I'm deeply American, and the idea of sitting down for breakfast every weekday morning just does not feel natural. I can't relax. I feel the need to get to

work. It's come to the point where *I prefer* to have breakfast while I'm at my desk—I can get my work in order, think, have some time alone. I'm unable to experience one of the most basic and simple moments in life. It makes me wonder about my priorities.

There's no doubt that the era of sitting down together for three meals each day is gone, in France and elsewhere. It is impossible for us to eat together that often, and honestly, I don't know that I would want my day to be dominated by family meals. Given how much we work—the hours on the job and also the time we spend commuting from home to work—it is even difficult to sit down and eat dinner together every evening, let alone three meals. Breakfast is eaten on the run, or not at all. Lunch is spent at our desks, in a cafeteria, or at a restaurant. If you have children, you trust their schools will provide a healthy lunch, in terms of both nutrition and environment, which, if school lunch programs are anything like they were in my midwestern public school, is purely wishful thinking.

In France, some families still meet for a sit-down lunch together, even during the week. Children are given

more time for lunch in French schools than I had growing up. My children, for example, had two hours for lunch in their village school in the south of France. Like their classmates, my son and daughter walked home each day to eat what was supposed to be a three-course meal at *midi* and returned to school at two. This daily event was a huge adjustment. As I mentioned, I tend to work through meals, so scheduling a two-hour daily break *right in the middle of the day* was difficult. Not just taking the time, but also making sure lunch was ready at the right moment, cleaning up after, the whole process of shopping and cooking and disassembling the meal was, well, a challenge. I began to see the full extent to which my American upbringing had trained me toward efficiency. I would sit down with my children but, after half an hour or so, I was ready to get back to my office to work for the remainder of the day. I didn't linger and talk to them about school or homework. I couldn't enjoy the moment of calm and pleasure with my children. I was hardwired to work. The practice of mealtime, and the importance of this ritual as a daily event, wasn't part of my life.

The French don't have this problem. They like to eat, and they like to eat even more as a group. Food is, above all, the symbol of French heritage, and the communal meal is bound up in French identity. The French call this sort of thing *patrimoine*, or the rich cultural traditions that have been passed down through generations and inform the unspoken habits and expectations that drive a French life. Often, these traditions happen at the local markets, where vendors give their clients recipes, advice about wine pairings, suggestions about what else to serve, and the story of how their fruit and vegetables (or meat and cheese, etc.) were produced. It is through the buying, selling, cooking, and eating of food that many French cultural traditions are passed down.

But this transmission is most often achieved through the act of eating. The most famous example of this is *le repas gastronomique*. This communal meal exemplifies French culinary art and is a signature element of French culture. In fact, it is so precious that *le repas gastronomique* was added to the UNESCO list of Intangible Cultural Heritage treasures in 2010, a list that highlights cultural traditions threatened by the changes

of the modern world, including the rumba in Cuba and the Nachi Fire Festival of Japan. Although everyone recognizes traditional food rituals in France, many are unable to make them part of daily life. They, like me, are too bogged down by work and family and friends to spend hours shopping, cooking, eating, and cleaning up. But what is at stake is more than just the absence of a good meal (although according to my husband, that is bad enough), but the loss of a way of life.

Enter *la salle à manger*. The dining room is the home of *le repas gastronomique* and most other French meals. It is a nineteenth-century bourgeois invention, the idea of having your meals in a single room. According to Nadine de Rothschild, whose exhaustive book of French etiquette *Le Bonheur de Séduire, L'Art de Réussir* (which translates to *The Happiness of Seduction, the Art of Success*) advises the French how to live in the modern world, it used to be that people ate wherever it so pleased them—near an open window in spring, at the fire in the winter, in the bedroom late at night, and so on. With the development of the dining room in the nineteenth century, and the rise of a middle class with enough money

and leisure to entertain at home, the dining room became the nexus of communal life, the place where family and friends met and renewed their connection to one another both physically and emotionally. It is no exaggeration to say that mealtime is the most important ritual in a French person's life, and it is treated with care and respect. In fact, dinner is considered sacred in many French homes and the dining room is the space where this sacrament plays out. If it sounds religious, that is because it is. In some ways, eating rituals have usurped religious ones for many French people. It's easy to speculate that the profound secularism of modern France has pushed the rituals of religion out of church and into the home. Whether this is true or not, the fact remains that a French home revolves around the dining room.

In our busy, multitasking, digitally saturated world, it is hard to imagine a total separation between eating and all other activities. *But the primary rule of the French salle à manger is that there must be no distractions during mealtime.* No television, no phones on the table, no loud music playing. Create a welcoming atmosphere and get everyone you love to the table as often as possible. Din-

ner is a sacred ritual, one of humanity's most necessary activities, and it requires something akin to reverence. When you are seated at the table in your *salle à manger*, you have one purpose: to focus on the pleasure of food, the warmth of friends and family, and the skill of the cook. As it is becoming an ever more rare event to eat with others, it is especially important that we give the gift of our attention to the food and the people with whom we eat when we do. In France, this is not an option. Attention and participation are part of the ritual of eating and the joy of being among friends and family.

This is not as easy as it sounds, especially if the structure of your house or apartment resists the concept of a *separate* dining room. When my husband and I lived in New York City, this was precisely our dilemma. Our modern apartment didn't have anything resembling a dining room. The kitchen was part of a continuous space that included the *entrée*, dining area, and nook for a couch. It was a large (by New York City standards), modern, two-bedroom, two-bathroom apartment, with a wall of glass windows that overlooked the East River. We both loved the apartment, but we also understood

that we wanted to have the spaces distinct, and most important of all, a dining room. We wanted to eat at a table and not at the kitchen counter. We wanted to have an *apéro* in a space away from the cooking. But our plans for our home went against the structure and function of the apartment. It was a space designed for optimum efficiency: every room moved into another room. The lights were multifunctional, the kitchen lights illuminating the dining area, and the hall lights the nook for the couch. We wondered if French ideas about distinct living spaces, and the rituals that went with them, could possibly work here. Maybe a modern apartment must be a modern apartment. Unless we remodeled, there was not a lot we could do.

We began experimenting, and we were able to restructure the space in small ways. We created an *entrée* with a few strategically placed items—a coatrack, shoe rack, the photographs. The kitchen counter created a division between where we cooked and where we ate. To further emphasize this, we put a rug under the dining table, to give the area more of a feeling of separation. Although we didn't have a physical wall between the dining

room and the kitchen, we had the semblance of discrete spaces. After cooking, we closed down the kitchen, carrying everything to the dining area, turning off the kitchen lights, and walking the twenty feet to the table to share our meal. We made sure the dining area had its own distinct lighting—sometimes dimmed electric lighting but often candles. The effort was worth it. Every night, we sat away from where the cooking happened, in a distinct location, experiencing the pleasure of eating together without distraction. We had, even in our crowded apartment, a true *salle à manger*.

One afternoon in France I was invited to the home of Monsieur and Madame Blanc,[*] a couple who live in the 7th *arrondissement* of Paris. Theirs is a spacious three-bedroom apartment on the top floor of a typical Haussmannian building near Les Invalides, the majestic monument where Napoleon is buried. When we arrived, they invited Hadrien and me into their *salle à*

[*] Their name has been changed.

manger, where we ended up talking about the idea of the weekday family meal.

They, like many French families, believe that dinner is the most important ritual in family life. The difference, however, is that the Blanc family sits down in the *salle à manger* every weekday night. In principle, this is what most French families aspire to do. But it is rare to find a family that actually still manages to do it today. I try to get my family at the dinner table a few times per week, and often have to be satisfied with a two-tiered system: the kids eat first, the adults later. I've compensated for this by making Sunday afternoon lunch a family meal. But for the Blancs, it is a family rule, a ritual that everyone can depend upon: no matter what else is happening, they set the table and eat together Monday through Friday. They also invite friends to dinner, and this helps them to keep their own friendships alive while still being available for their children.

"Sometimes, if we're working late, we don't eat until eight thirty. After dinner, the kids bring their homework to the table and we help them before they go to sleep," Monsieur Blanc told me. "We often invite friends to join

us for dinner, so we're able to have a strong social life while being at home with the children. The important thing is that we are all together for an hour or so every night."

"Our weekday dinners aren't fancy," Madame Blanc added. "We often have leftovers or even takeout. What makes them special is the effort we make to be together."

Together is the essential word and idea: the point of their meals is not so much the *eating* but the *togetherness*. Although food is important, and a great part of the pleasure of the ritual, it is the act of setting the table together, sitting down together, sharing the meal together, and cleaning up together that is so important. In many French families, parents insist upon assigning their children chores at mealtimes. In one family I know, the children are required to help cook and serve meals at their parents' dinner parties. They bring around dishes of meat and bottles of wine, clear plates, serve dessert, and fetch napkins. The first time I encountered this, I was a bit shocked. "They treat their kids like servants," I'd whispered to my husband. He explained that the point was not to force the kids into labor, but to *include* them

in the creation of the event. They become invested in the meal. It yanks children out of their isolation—whether it be getting them off their phone or away from their computer—and thrusts them into the life of the family and the world of adult interaction.

The Blanc family uses the most central room in their apartment for the *salle à manger*, a long space with casement windows looking out over l'École Militaire, the eighteenth-century military complex just southeast of the Eiffel Tower. Tucked between the *salon* and the children's bedrooms, the dining room is in a position that allows friends to move easily to the dinner table after an *apéritif,* and, if the evening goes late, for the children to slip off to their bedrooms.

Generally speaking, the *salle à manger* is a simple space in most French homes. The central feature should be the dining table. In my home in the south of France, for example, our long oak farmhouse table stretched the length of the room. There was just room enough for a *vaisselier,* or hutch that held dishes, glassware, and silverware, and a small marble-topped side table for hot dishes. Although I've seen many elaborately decorated

dining rooms, mine was more the norm. There were no paintings on the walls or objects on display in my *salle à manger*. The purpose of the room was sharing a meal.

The Blancs' *salle à manger* is equally spare. There is a long glass rectangular table that seats eight to ten people at the very center. Discrete built-in cabinets hold dishes, glasses, and serving bowls. The china and other fine dining equipment is also stored here, never in the kitchen, where one will only find everyday dishes and glassware. There is a *coffre*, or case for the silverware, and another drawer filled with linen tablecloths, cotton napkins, and woven place mats. On the mantel of their white marble fireplace, there stands an array of glass candleholders, the candles burned down in folds of creamy wax. Everything needed to set a table for a communal meal is there, ready and waiting, in the dining room.

The protocol of the informal family meal is simple. Everyone, including the children, participates in setting the table. A few candles are lit, the lights dimmed, and everyone eats and exchanges information

and opinions about the day. The French love to talk. Speaking well, and with humor and wit, is a sign of intelligence in France, which can make it hard for the linguistically challenged foreigner to break into the inner circles of French life. Sometimes I think that the communal meal is as much an excuse for exchanging information as eating. Everyone is part of the conversation. It is expected, in a French family dinner, for children to share their thoughts. It is also quite common to hear political opinions, family gossip, jokes, and discussions about books and films during meals. The content of the discussions matters less than that everyone is at the table together, without their phones or iPads or other distractions, communicating face-to-face about the world they inhabit together. And while this may seem easy, I remember my teenage self refusing to say anything during a family meal. I preferred to read a magazine at the table and then slip off as soon as I'd finished eating. This wouldn't fly in a French home. In fact, the very idea of *not* participating would be so unacceptable, so intolerable, that it wouldn't occur to the teenager in the first place.

There are generally *three main courses* to the informal French meal: First, an entrée of salad, sliced meat or *charcuterie*, soup, cheese, and bread. Wine or beer will be served. Children are given water, sometimes sparkling water, sometimes still. It is rare for children to drink juice, soda, or any other flavored drink with dinner in France. Sometimes they are given a sip of wine, so they can grow to appreciate the taste. Wine is considered to be as much an element of the meal as bread or meat, and drinking too much is viewed with the same disapproval as overeating. Portions are regulated. It is expected that children will grow up understanding limits, with both food and wine.

When my husband moved to the United States with me, he was delighted to find that the portions of everything, from sandwiches to steaks, were larger than they were in France. He loves to eat, and so he dove into American-size meals with pleasure. After his first year in New York, he had gained fifteen pounds. He hadn't eaten different kinds of food—he had three meals a day, lots of vegetables and fruits, and avoided junk food. He had gained weight from the portions alone.

It was fascinating for me to watch his reaction to the way Americans eat. Not only was he genuinely perplexed by our habit of eating and working, or having an after-dinner drink with a burger, or skipping meals entirely, he was astonished to find that some of his new friends in America drank with the purpose of getting drunk and admitted to doing so openly. In France, it is nearly unheard of to admit to binge drinking. Maybe this is because French children are allowed to have a small amount of wine with their meals from an early age—they are encouraged to taste and appreciate wine—and thus the mystique and transgression of drinking alcohol is diminished.

After the entrée, a main course of fish, meat, pasta, stew, or some other hearty cooked dish will be served. The French always serve bread with their meal, and it is never served with butter (except at breakfast, on toast or *tartines*), and so there is never butter on the table during dinner. The French usually eat baguettes with dinner, and they slice or rip off a hunk of the bread and leave it on the table, not on their plates. You will know that you had a real French meal if your table is full of crumbs.

One bit of French table etiquette that I love re-volves around the beloved French baguette. In addition to leaving it on the table, the baguette is used to clean your plate. Some people hold bread in their fingers while sopping up liquids on their plate, but if you want to do it properly, you will break off a small piece, drop it on your plate, and use your fork to move it around the plate. Once it is soaked to capacity, use your fork and knife to eat it.

Last, there will be dessert, cheese and more bread, fruit, or yogurt to finish the meal. Sometimes there is just one of these options—a pie from the patisserie, for example—and sometimes there is a combination of all of the above. My husband's family is very *gourmand*—meaning they love to eat—and so there is often dessert, cheese, fruit, and yogurt at the end of a meal. And no, not one of them is overweight.

A short note about table manners: the French eat with their knife in the right hand and their fork, tines down, in the left, cutting and eating in one gesture. Many Americans, of course, cut their food, place the knife aside, and use only the fork to eat, often switch-

ing the hands in the process. The French don't rest their hands in their laps during a meal, and they are careful not to let elbows slip onto the table. Americans do rest hands in laps between courses, they sometimes let elbows float onto the table, and they wouldn't think of putting bread on the tablecloth.

There are many intricacies to both French and American table manners, enough to fill an entire book. My husband says that even after a lifetime in France, he still doesn't know all the rules. The French will correct each other's manners at the table, but it is often seen as a kind of game. When we're in New York, I playfully correct my husband's table manners, and in Paris, he corrects mine.

What my American self loves best about the informality of French family meals is that they feel so *unfussy*. The courses are fluid, without any hint of snobbery, and everyone enjoys the process of eating while remaining within very clearly defined protocols. Everyone sits down at the same time and no one begins eating until everyone is together. Once the meal starts, dishes are passed back and forth freely. Everyone talks over each other, every-

one adds to the conversation, and the ambiance is light. Wine is always served with even the most informal meal, but beer or water is usually an option, too, and there are no strict rules about what adults drink. Children are generally allowed to have water, or a sparkling lemonade such as San Pellegrino, or a little bit of wine. No one ever drinks juice or milk with a meal. Ever. I remember one American telling me that she had requested milk with dinner and it was such a shock that the French analyzed the choice—from the health benefits to the origins of the custom—for half the meal.

Although it seems like there are a lot of rules, in the many informal family dinners I've shared with my husband and his family, there is a freedom that feels cozy. In fact, the French family meal is as informal and playful as our American dinners. The only difference—and this is the crucial element—is that they always take place around the dining room table.

Formal dinners in France are a bit more choreographed. Birthday dinners, dinners involving work

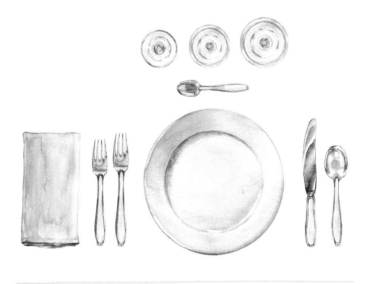

colleagues, holiday dinners (especially Christmas and New Year's Day) are all generally celebrated with a formal meal. For these occasions the dining table will be dressed with a tablecloth, flowers, and candles. The arrangement of the dishes, glassware, and silverware is always the same at these dinners. Nadine de Rothschild advises that plates are placed two centimeters (about an inch) from the table edge and sixty centimeters (about two and a half feet) from each other. She suggests that

plates never be stacked upon each other, except in the case of a soup bowl, which can be placed on the dinner plate, and removed after the soup has been finished. The knife goes to the right of the plate, the edge turned in. The soup spoon is placed to the right of the knife, facing up. On the left, there will be an entrée fork and fork for the main dish. Sometimes you will find a small bread plate above the forks, but Madame de Rothschild suggests to ignore it: a bread plate is all for show, and most French people just ignore it and still put their bread on the tablecloth. Above the dinner plate, you will find a small dessert spoon. The water glass will be placed above the dessert spoon, to the left. A red-wine glass will be directly above the dessert spoon, and a white-wine glass next to the red. Champagne is served as an *apéritif* or with dessert, never with the meal itself.

When expecting dinner guests, on formal and informal occasions, you would be wise to make a *plan de table*, or seating arrangement. It may seem old-fashioned, but it is very much a part of the modern dinner party world in France. In the many dinner parties I've attended, from the south of France to Paris to Brittany, there has never

been one without arranged seating. As the highlight of any French evening is the exchanges that happen across the table, the seating plan is the most essential element of your dinner party, equally as important as the food and wine you serve, and will ensure that interesting conversations take place, new connections are made, and old friendships reaffirmed. Nadine de Rothschild gives a number of different table plans, depending on the size of your group (a plan for six, ten, fourteen, and eighteen), but the basic rules for every table plan are as follows: the hosts of the dinner—traditionally Madame et Monsieur, but in the modern world includes Monsieur et Monsieur and Madame et Madame—sit at the midpoint of the table, across from each other. Men and women are seated next to each other, and couples are never seated together. In fact, partners are ruthlessly separated, unless you are a couple in the first year of marriage, and then you are allowed to remain together. Table cards, Nadine de Rothschild suggests, should be created for all dinners of more than eight people. After analyzing the personalities and interests of your guests, you place them where they will

be most likely to find kindred spirits. Enforcing your seating arrangement can be difficult. I have attended dinner parties where guests have surreptitiously changed their table card so as to be seated next to someone more interesting. But you must be firm, and change the cards back. The proper *plan de table* allows the group to mix and impromptu conversation to arise.

Traditionally, the host serves the wine while the hostess serves the food. Women are served first—both wine and food—in order of age, the most senior woman being served first, the children being served last. Although it may seem silly to create a hierarchy by age, it is a sign of respect to serve your guests properly. I have been at large, formal dinners that have a special table for the children, but for smaller dinner parties (those with fewer than twenty people), children are integrated into the seating plan.

The meal does not begin until everyone is served. While the meal is being prepared in the kitchen, an *apéritif*—drinks and hors d'oeuvres—will be served in the *salon*. Then, from the kitchen, one hears "*À table!*"

and everyone makes their way to the *salle à manger*. Everyone finds their place based on the *plan de table*, *Bon appétit* is said, and the meal commences.

My husband has noted, and I've heard it from other French people, too, that this phrase is sometimes considered passé by some. I take this with a grain of salt. It is a badge of honor to be contrary in France, to argue with the establishment about traditions, even as you adhere to them, and so when I see the French rolling their eyes at their traditions, I'm not surprised. For me, this is a ritual that signals the meal has started, a little like the blessing in a traditional Christian house, or *itadakimasu*, the Japanese phrase for *I humbly receive*, which is always used before eating. *Bon appétit* creates a demarcation between activities, the meal preparation and the act of eating. And so, I am on the side of those who choose to say it.

A formal, communal French meal plays out over many more courses than the traditional three, and can last hours. When the food and wine are good, the company interesting, a three-hour meal doesn't feel very long. I have been to many Sunday lunches that stretched on into a late afternoon discussion of art or politics over

coffee, transformed into an *apéro* at six and then, at seven o'clock in the evening, became an *apéro-dînatoire*. We spent an entire day eating and talking, and it didn't feel like anything but pure pleasure.

TRADITIONAL COURSES IN A FRENCH MEAL

APÉRITIF OR *APÉRO*: A predinner drink served with nuts, pretzels, or chips. Kir (crème de cassis and white wine) or a kir royal (replace the white wine with Champagne) is a traditional favorite, although a dry wine is also very common, and a chilled white or rosé wine is often preferred to the sweeter kir. My husband often has beer before dinner. Before a large meal, the *apéritif* is generally served in the *salon* while the host finishes up preparing the meal, setting the table, and bringing the dishes to the *salle à manger*.

ENTRÉE: This is the first course of a meal and can be anything from salad to a simple vegetable dish like carrots with butter or green beans to

soup. When you hear about the French eating *escargot*—snails baked in a delicious parsley butter sauce in their shells—it is as a first course. *Escargot* is perhaps one of the most foreign for Americans, as is another favorite, *steak tartare*, raw ground beef mixed with a raw egg and seasoned with Worcestershire sauce, parsley, capers, and chopped onions, although there are many French people who would rather have this served in a bistro than at home. My mother-in-law, for example, will eat *steak tartare* only when it is prepared in front of her at a restaurant, for reasons of taste and hygiene. I was shocked when my mother, who grew up in the Midwest and has a classic American taste in food, tried *steak tartare* at a Paris bistro and loved it. Depending upon the size of the portion, *steak tartare* can be eaten as an entrée or a main dish.

PLAT PRINCIPAL: The main course of your meal is usually fish, poultry, or red meat. There are very few vegetarians in France, but they are becoming

more common. Pasta and couscous are other common main dishes, especially for less formal meals, when there isn't much time to make an elaborate dinner.

CHEESE: Cheese can be eaten directly after the main dish and is often served with salad. A fresh baguette is sometimes brought out for the cheese course. It was interesting for me to learn that the milk used to make the cheese often dictates the type of cheese someone chooses. Goat milk cheese, cow milk cheese, and sheep milk cheese are the three main options, and it is generally considered good taste to have one of each kind on your cheese plate. It is also frowned upon to have fruit on your cheese plate. This was a surprise to me, who had always served grapes with cheese. But traditionally, the cheese stands alone.

SALAD: There is some debate about when to serve the salad. In Paris, it is generally served at the end of the meal. In the south of France, it is very often served first, as an entrée.

FRUIT: There's usually a bowl of fruit brought out with, or just after, the salad course.

DESSERT: Yes, sometimes there is cheese, salad, fruit, *and* dessert. Which is why Sunday lunches can go on for the entire day.

CAFÉ: Coffee is served with dessert. If conversation is going strong, sometimes a second one is served.

DIGESTIF: Every so often, especially at long Sunday lunches, a *digestif* will be served after coffee. Cognac, Armagnac, calvados, or one of any number of liquors or *eau-de-vie* will be served in small glasses. The point is to assist in the act of digestion which, at this point, after so many courses, is greatly needed.

Aside from multitasking in our American living spaces, one of the biggest obstacles faced in the creation of your *salle à manger* is *snacking*. Snacking has a negative effect beyond your waistline. The foundation of a

successful dining room is the family meal. The family meal can only happen if everyone is hungry at the same time—dinnertime, for example, which in France skews a little later, around 8:00 P.M. If snacking has taken place at 6:00 P.M., and you aren't hungry when dinner is served, then the family meal is ruined. Everyone is hungry on their own schedule. Kids might eat at one time; parents at another. It's a problem I see all the time in my own family.

It is difficult for a French person to understand the American habit of eating whenever the mood strikes us. This can create enormous culture shock to French people trying to understand the way things are done in the United States. They don't understand that instant gratification around food—like most everything else—is woven into the very fabric of our culture. We're hungry now and so we eat now.

Madame de Rothschild gives a rather byzantine list of rules for eating correctly, but the ones that I've seen most often are the simplest: never eat unless truly hungry, and never until you are full. Never eat between meals and then only fruits in the afternoon.

The French have learned to wait and, in fact, find pleasure in waiting to eat. It is even so with fast food. The French eat fast food often—the French are the second largest consumers of McDonald's, after Americans—but they almost always eat MacDo (as they call it) seated at the table *en famille* at the regular lunch or dinner hour. It is a replacement for a sit-down family meal, not an addition to one. The transportable, unscheduled, and on-the-go meal confuses French people. Monsieur Blanc recalled a trip he took with an American family between New York City and Washington, D.C. They drove, and their trip should have taken about four hours total. But they were delayed many times, he said. First, his American traveling companions stopped for snacks, then drinks, and then—after drinking too much—bathroom breaks. Every hour or so, they stopped. They made the trip in six hours, and when they arrived, no one was hungry for dinner. *Quelle horreur!*

I've been embroiled in the American/French snacking battle. I'll never forget one morning, early in our relationship, when Hadrien and I were walking together in Paris. It was an hour or so before lunch. I hadn't had

breakfast, and (big surprise) I felt hungry. I wanted something small to eat—just a nibble to get me through to lunch—and was looking around for a place to buy a snack. When I told him this, he looked at me as if I were totally insane.

"Well, of course you're hungry, you didn't eat breakfast!" he said.

When I explained that I wanted a snack, and that I'd still be hungry for lunch, he stared at me with a lingering, incredulous gaze.

"No, you will ruin your appetite for lunch, and then what will we do? Skip lunch? No way. *Impossible!*"

We had a serious moment of Franco-American tension right there on the street, both of us irritated and confused. He didn't understand that in my world, it is perfectly acceptable to buy something to eat when you're hungry, even if it is eleven o'clock. The problem, of course, was that I had skipped breakfast. This threw off the entire rhythm of the day for Hadrien. Now I was about to ruin my appetite for lunch, which would destroy the possibility of sharing a meal together, wiping out all hope for a beautiful, shared moment. *There is nothing*

wrong with being hungry, he grumbled as I stopped at a bakery and bought a croissant.

It was clear: my American eating habits were at odds with his French ones. He didn't understand that in my culture, we are *encouraged* to eat when we're hungry. And I didn't understand that in his world, eating between meals is totally and utterly unacceptable. It is simply not done. Not only is it bad manners, it breaks with all the rituals of communal eating. It also means you are something of an undisciplined egoist—you are willing to satisfy your hunger to the detriment of everyone else.

Snacking poses a real problem for French people. Not because it is unhealthy *per se,* or because they don't like the taste of snack food, but because they simply don't have a room for it. Traditionally, the French do not eat between meals. When they do, it is given a ritualized function and a name, such as *goûter,* the traditional snack kids eat after school. Often this snack is served at the kitchen table, but sometimes it will be a pastry or cookie bought at a bakery near the school. Near my children's school in the south of France, the baker had a special *goûter* box: a *pain au chocolat* and a Capri Sun

juice box for two euros. Parents buying their children these boxes wouldn't say their children were *snacking*. They would say their children are having their *goûter*. The difference? A *snack* is unorganized, impulsive eating. *Goûter* is a shared ritual, sanctioned by the entire society and shared each day at the same time by every child in France.

I was reminded of the intense feelings the French have for their *repas gastronomique* most recently when Hadrien, who is a filmmaker, was in Washington, D.C., working on a project. On set, the crew eats together, and while their meals are generally catered or brought in from a restaurant, there was one evening when they all decided to cook a meal and share it. My husband's French sentiments bubbled up and he began planning a feast. They bought pork chops and salad and wine and all the ingredients for his mother's famous *ratatouille*. I was at home in New York and was regularly updated on the progress of the dinner party by text message. Everything seemed to be going well until it was time to eat.

Suddenly, a stream of frantic messages began blinking onto my phone: *What is happening? They are not even setting the table!? Everyone is eating in the kitchen? It's not even dinnertime! My ratatouille needs another hour to cook. They are taking plates and eating meat while standing up! What is happening? I can't eat this way! There is no respect!*

After getting more of the story, I understood that my husband's coworkers were taking plates and serving themselves as soon as the food was ready, then sitting down wherever was comfortable—in the kitchen, living room, dining room, back terrace, wherever—and eating as others continued to cook. This BBQ buffet-style meal is part of American culture, but it is just plain weird for the French. For my husband, a meal that has taken time and expense to create must be eaten sitting down at a table in the dining room.

Sensing that Hadrien had hit upon a major difference in how we use the *salle à manger*, I asked him what he meant when he said there was "no respect." I pushed him to explain what he felt. Finally, he replied: *You must respect the animal, the food, the time spent cooking. Eating is about togetherness.* Later he wrote: *Everybody here eats*

whatever they want, whenever they want it. They are not hungry together or sitting together or enjoying the food together. His reply was about the ways we think of community and individuality, togetherness and separation, all of which plays heavily into the French home and the French way of seeing the purpose of the dining room.

My husband's feelings about this incident got me thinking about *respect,* and the way he conceptualized respect in this situation. Respect for eating rituals is one of those things that seems antiquated and stuffy when we use them in the United States. We rolled our eyes at the idea as teenagers and disregarded it as adults. But there is something more than hollow pontification in this idea of respecting the ritual of dinner. By respecting the cook, respecting the food, and respecting the togetherness we feel when we eat, we are honoring the bond between ourselves and others. We are creating relationships or, if these relationships are well formed, we are maintaining them. It is an appreciation of the sacred human ritual of gathering food, creating a meal that will nourish and sustain us, and sharing it with the people we care about. Somehow, in our modern world, we've lost

the ability to cherish the most important elements of our lives: respect for our health and our relationships. We can start to reclaim that respect by simply creating our own *salle à manger.*

THE *SALLE À MANGER* CHALLENGE

After speaking with the Blanc family about their weekday family meals, I decided to try this myself. My goal? To sit down for dinner every night with my family for one month. You can do it, too. First, arrange your dining room so that it will be easy to put together a family meal each day without excessive preparation. You don't have to make a fancy meal. It doesn't even have to be homemade. But if you're bringing home Chinese takeout or pizza, remove the food from the cardboard or plastic boxes, put it in bowls, and serve it on the table so that it can be passed and shared. Add a salad, or another simple first course, and a dessert, so that you eat in three courses. Try to make it simple, the courses fluid. In the end, what you eat doesn't matter so much

as the fact that you are eating together, without distractions. That means no telephones, no books, no magazines, no television, and no computers anywhere near the *salle à manger.* For one hour, block the outside world and live in the universe you've created. After doing this for one month, I found that it became a habit. Now, it is the rare evening when my family doesn't eat together in this fashion.

Salle à Manger

DINING TABLE: A large dining table is the focal point of every French *salle à manger*. It must be big enough to accommodate your entire family, plus a few friends, and even have the option to expand for maximum flexibility if your home has the space.

VAISSELIER, HUTCH, OR CABINET: This piece of furniture serves two purposes—it not only makes your finest dishes and prettiest tableware visible, but also holds the silverware, tablecloths, napkins, place mats, napkin rings, flower vases, candleholders, and other items you will use on your table.

LIGHTING: There should be flexibility in the lighting in your *salle à manger*. Install a dimmer switch if

you have overhead lighting. Or rely on candles and natural light.

SEPARATE SPACE: Remember, you must create a division between your dining room and your kitchen to truly have a *salle à manger*. Do this with a rug to change the texture of the area under the table, with distinct lighting over your dining table, and with pieces of furniture that create some feeling of separation.

4

La Cuisine

My admiration for the French kitchen, or *la cuisine*, was born—like my love for French homes in general—at Jacqueline Manon's house. My mentor in the good life was an excellent cook and had a kitchen in which she created dinners I have never forgotten— coq au vin, bouillabaisse, boeuf bourguignon. She always claimed that she had the best kitchen in town, and I had to agree. Her kitchen was a small, densely packed room located at the back of her house, hidden from the living

room and the dining room. Built in the nineteenth century, Jacqueline's home was constructed at a time when kitchens were not a place to entertain and was therefore structurally similar to many French homes. She considered her work technical, almost scientific—she would never throw in a pinch of this or that but measured ingredients, and she was rigorous about having the correct equipment for her task, including hard-to-find French objects such as a bain-marie (a double boiler that allows steaming) and a *tagine* (a casserole with a cone-shaped top). By the time I met her, she had collected every kind of tool to aid her in her art—copper pots and cast-iron baking dishes, and a large freestanding dough mixer stationed on a wooden table. From the kitchen sink, you could see her garden—a robust and fertile mixture of flowers and vegetables. When it was warm, she would open the door to the backyard and step out to pick fresh ingredients. She would walk out to the backyard barefoot, returning with a basket of ripe tomatoes, dropping them on the kitchen counter, take a razor-sharp knife from its spot—all her knives were carefully sharpened and stored—and get to work. Every piece of equipment

was in place, and she grabbed mixing bowls and pans instinctually, without thinking. Each time I walked into Jacqueline's kitchen and saw her method of cooking, the unconscious precision and rigor of her work, some little mechanism would click in my mind, and suddenly the world seemed to make sense.

If the dining room is the heart of a French home, the kitchen is its brain, a functional room that brings systematic logic, order, and skill together in one technical space. Of all the rooms in a French home, the kitchen is the most modern, the least burdened by tradition or the weight of public display. Unlike the *salon* or the *salle à manger*—spaces designed for groups and guests—the kitchen is considered a private room, a place closer in spirit to the *cave*—which is its alter ego—and the bathroom, which is equally hygienic, sanitized, and unadorned. A French kitchen may be elegantly designed, with a traditional, high-quality, and outrageously expensive La Cornue stove and hand-painted Provençal tiles, but whether you spend a fortune on equipment or stick to the basics, *a French kitchen is a space with one purpose: the preparation of food.*

First and foremost, the French kitchen is a work space, a purely *technical* room. It isn't a place where you hang out or relax and have a drink. It is not meant to be comfortable, or expressive of the cook's personality. It's not the room where you hang colorful wallpaper or your favorite pictures, or put a comfy couch. It's a clean unencumbered space, a *tabula rasa* for the cook, whose purpose is to bring science and technique together to create something ephemeral and poetic: a delicious meal.

The essential purpose of the French kitchen is as a work space. Like a laboratory, the French kitchen is meant to provide an organized and efficient space to support the serious task of caloric conversion and chemical fusion into something sensual. When you think about it, even the simple act of making coffee is an act of chemical change. The alchemy of turning a collection of disparate ingredients into a harmonious and delicious meal requires not only the proper tools but also the right technique to use those tools. I have seen many American kitchens that were better equipped, with more expensive gadgets and high-end appliances, than some French kitchens, but they were wasted because the cook didn't

know how to use them properly. *You need the tools, but more important, you need the correct purpose behind the tools.*

It's easy to forget that the kitchen as we know it—both in France and in America—is a relatively recent development. During the Middle Ages, meals were cooked on an open fire, most often in a fireproof building that was either physically separate from the house, or isolated enough for a fire to be contained, should one erupt. Average people didn't have much more than a hearth, and wealthy homeowners never saw the kitchen at all, having employed servants to cook. In the eighteenth century, French and American families huddled around the fireplace, cooking, eating, and sleeping before the fire to stay warm. It wasn't until after the French Revolution in the late eighteenth century that rooms began to have distinctly separate functions for average people, the kitchen being the most distinct, probably because it was considered the most unsavory room in the house. Back then, kitchens were described as stinky, dirty, shameful, and *infréquentable* and were to be avoided at all costs. The scullery—which was often a separate vestibule adjoin-

ing the kitchen—was called the *souillarde*, a word whose root means "dirt" or "stain." The women who washed dishes were known as *souillardes*. Clearly, nobody liked the kitchen, let alone wanted to linger.

Not until the twentieth century did the kitchen become a desirable space. In the 1920s, the first refrigerators arrived in France, and then in the 1940s, after the war, American-style modular components were imported. The French adopted American-style kitchens, happily swapping coal- or wood-burning stoves for gas or electric ones, and refrigerators for iceboxes. Suddenly, kitchens became sanitary, airy, and pleasant. Gadgets for blending, chopping, and mixing also became cheap and popular. Food storage—for both fresh and frozen food—became viable. In this regard, the modern French kitchen is intimately tied to the technology and philosophy of American kitchens. The French love precise, technologically advanced devices that assist them in creating traditional meals faster, without the problems of old equipment. They even love frozen foods, and microwaves, although the frozen foods are often traditional fare made on a Sunday afternoon and stocked away, or

upscale frozen meals from the store Picard. Cooking in France began to be viewed as a set of technical skills, not as the drudgery it was in previous eras. With the right tools, and the right frame of mind, one could master the elements and create a work of art. The French kitchen became a serious work space, where the chemistry and science of food was perfected. The kitchen is the most *Cartesian*—the most categorically organized and rigidly systematic—room in the French home.

It is also the least traditional. This was the case even in my home in the south of France, which was built in the thirteenth century, long before the notion of a modern kitchen existed. The structural elements of the kitchen were very old, the walls constructed of ancient honey-yellow stone, giving it a warm, rustic feeling. In the modern era, pale yellow cupboards had been installed, as well as a wall oven and ample storage for pots and pans, making it a highly efficient work space.

Everything had a purpose in our kitchen. There was a marble counter for chopping and rolling out pastry dough with shelves for baking dishes underneath. There were cabinets and cupboards and a shelf for the micro-

wave. There was an induction stove top that could boil water in four minutes. The room contained nothing but technical objects and spaces meant for putting the meal together. It was self-contained, functional, and suited to one purpose: serious cooking.

We never ate family meals in my French kitchen. Not even the washing up happened in our kitchen, as there was no sink in that room. If we needed to fill a pot with water, we walked to a tiny room just off the kitchen itself, the *souillarde,* with a dishwasher and large, industrial sink with a spring spray faucet and a stainless-steel dish drying area. The trash and recycling bins were kept there as well, making this space primarily concerned with sanitation: disposing of waste and cleaning dirty dishes. The physical separation of the washroom from the kitchen made a clear distinction between the two activities, and reminded me every time I prepared a meal that my French kitchen was a cooking machine.

The *famille* Blanc's Paris kitchen is the picture of a traditional French *cuisine.* Long and narrow, with-

out room for more than a few people at once, the kitchen was built for the sole act of cooking. It is a pleasant space, with a window overlooking the slanting rooftops of Paris that pours light over the white cabinets, the countertop of gray granite, and the plain open shelves displaying teapots, espresso cups, *café au lait* bowls, and a mortar and pestle. The room has the quiet severity of a professional kitchen: there were no paintings on the walls, no colorful tiles on the floor or backsplash, no bright appliances to draw the eye. On the day I visited, I opened the cabinets to look inside and found them packed with pie tins, spice jars, sacks of flour, three varieties of sugar, rolling pins, bags of grain and rice, boxes of pasta, muesli, measuring cups. It was a cook's kitchen, in service only to their daily family dinners.

As I turned to leave the Blancs' kitchen, I noticed a small table set up against the wall with two stools underneath. The kitchen table was an object that perplexed me. If meals are eaten in the dining room, what was this? When do they use it? So far as I knew, French dinners are *always* taken in the *salle à manger*. Perhaps there were exceptions. When I asked Madame about her kitchen

table, she told me that she and her husband often had quick, informal breakfasts there. As there were only two stools, I saw that it would be difficult to manage more than this. Glancing at an espresso machine on the counter nearby, I imagined them having coffee as the early morning sunlight filtered into the room. They have a separate set of juice glasses, plates, and bowls just for this purpose, and a separate set of silverware—the silverware used for their formal family dinners was in the cabinet in the dining room. Their kitchen table breakfast would be informal and private, and yet it is as ritualized as their weekday family meals.

What I came to learn is that while there is always a clear separation between the acts of cooking and dining in a French home, there can be some flexibility. While cooking and dining never happen at the same time, quick, informal meals—ones that are cold or involve a toaster or microwave—are eaten on a small kitchen table, breakfast bar, or island in the kitchen itself, just like in the States. Not all French kitchens have this capability, but when they do, it adds a level of ease, especially in

the morning, for those times when it is simply too difficult, or the group is too small, to set the table in the *salle à manger*.

So while the French may tell you all meals are taken in the *salle à manger*, they are also sometimes, under certain conditions, eaten at the kitchen table. I believe this is called a French paradox.

It must be noted that there is a big difference between these two kinds of eating. Breakfast can be fast, functional, and eaten on the run as each person in the family makes their way to work or school, but a meal in the dining room is never improvised or quick. I've seen this very duality in my husband's family. The Postel-Vinays also have a small table in their kitchen, with stools that tuck underneath, much like the Blancs' kitchen table. They have breakfast there, but they will eat a quick lunch or dinner on this table from time to time. It is a place for informal meals, usually prepared quickly, a late dinner, or takeout eaten in solitude. The space is most often used when family members are missing, or when one eats alone.

The style of modern French homes is very different from my kitchen in the south of France and from the typical Parisian apartments built in the nineteenth and early twentieth centuries. Modern French homes have open spaces with enormous glass windows and sliding glass doors, just as American ones do. So you would think the French would behave differently in these new dwellings, using the dining room and the kitchen interchangeably, nixing the *entrée* and watching television in the *salon*. But to my surprise, this isn't the case. *The structure of a French home has very little effect on how the French think of the rooms in their houses. They still use each room according to its traditional purpose.* So, while a modern *cuisine* may flow into the *salle à manger*, it does not mean that the functions of the rooms change. This is particularly true of the kitchen.

Take, for example, the modern home of Danny, an old family friend of the Postel-Vinay family. One Sunday in April my husband, his mother, and I visited Danny in the suburb of Cachan, fifteen minutes south of Paris. It was something of a surprise visit—we'd called Danny at

the last minute and said we were showing up for lunch with oysters we'd bought at the market on Avenue de Saxe that morning. My mother-in-law knew I wanted to see French kitchens, and she thought Danny's would be a great example, so she called him up and told him we would be stopping by with a treat. Under most circumstances, this is not done. But Danny was a close friend, and loved oysters, so he welcomed the visit.

It was something of an ambush, and I hoped our surprise visit would leave Danny little time to change things from the usual day-to-day arrangement. I had met our host several times and was looking forward to seeing his home, which my mother-in-law had characterized as a beautiful, modern place with a large garden and a stunning view. Though he lived alone and had grown children, he had an active social life, often hosting his girlfriend and friends at his place. He also loved to cook, and his kitchen was bound to be worth seeing.

As it turned out, Danny's home was airy and light filled, with large windows and high ceilings. The kitchen was the smallest, and most secluded, room on the main

floor, but it was, to my taste, wonderful, a perfect example of what makes French kitchens my favorite kitchens in the world. The space was long and deep, with a large window overlooking his garden, a simple counter, sink, and dishwasher on one wall and a wall of cabinets on the other. When no one was looking, I took a peek inside his cabinets and found glassware and dishes all arranged in neat, glistening rows. I have come to understand that the French don't mix and match their stemware, and Danny's glasses were all of the same brand, uniform in size and color, with the same number of each kind of glass arranged systematically on tiered shelves: red-wine glasses, then Champagne glasses, white-wine glasses next, water glasses on the bottom. His dishes were equally classified. Uniformly white, they were all made by the same company, and stacked neatly by size and purpose. Soup bowls, salad plates, dinner plates, and dessert plates were all precisely placed. *He had created a taxonomy, one that was functional, beautiful, and practical.*

But while the taxonomy of Danny's cupboards was impressive, I was stopped in my tracks by the cutlery. Let

us pause a moment to consider the marvel of the French silverware drawer.

The French ability to arrange a kitchen drawer is a work of art, one that forever inspires my admiration. It is like ikebana, the Japanese art of flower arrangement: It seems so very simple—you just throw some flowers in water randomly—but, in fact, a well-organized kitchen drawer is a skill that is learned through practice over time. With ikebana, there is not one rule that creates the perfect flower arrangement. It's the intersection of a lifetime of seeing such arrangements, a deep understanding of the Japanese aesthetic of minimalism, and a lot of practice that makes the floral arrangement gorgeous. So too with French kitchen drawers: the entire culture is behind their perfection.

Needless to say, I have not mastered this art quite yet. I will never forget the first time my mother-in-law came to visit us in New York City. She was not yet my mother-in-law at the time actually, and I felt nervous, not only because she was my boyfriend's mom, but also because she was my French boyfriend's *French mom*. I knew that French mothers have very particular views about the

home, and so Hadrien and I cleaned the apartment and put everything in order. I was prepared, or so I thought.

On the first morning of the visit, my mother-in-law started her day by making coffee in our small kitchen. She was looking for something—sugar or a teaspoon—and opened my kitchen drawers in search of it. As she pulled back each drawer, I could see her growing alarm. Her eyes became large. She turned and looked at her son, confused. Where were the spoons? Why were the knives and forks mixed together with the measuring cups? She was seeing an American kitchen drawer for the first time. It was culture shock, pure and simple.

I will say here that my husband is a special kind of Frenchman, which is probably why he chose to marry an American. He loves France, but he appreciates some distance from his homeland. He understands the rules his countrymen live by, but he purposely, almost gleefully, breaks them from time to time. That said, I find that he has assumptions about how daily life should proceed—how we should eat, how we should fold the laundry, how we should organize the kitchen drawers—

that I simply couldn't understand. Living the way I lived—chaotic kitchen drawers and all—was part of the romance of living in America. When his mother looked askance at him over the state of our kitchen drawers, he merely shrugged, as if to say: We're not in France anymore, Mom.

Before this incident, I would have considered my kitchen drawers "good enough." There was one drawer with silverware comprised of a few different styles I'd collected haphazardly over the years, and included measuring cups; another drawer with glass and plastic storage containers, and cooking tools; one drawer with stacks of dish towels of various colors, styles, and sizes, plastic Ziploc bags, and a hand mixer; and another with miscellaneous things—rubber bands and a screwdriver and Krazy Glue and paper clips. All the remaining utensils and tools—spatulas, wooden spoons, whisks, etc.— were thrown together in a jumble in my biggest drawer. I had thought my drawers were organized. But they were not organized like French kitchen drawers. They were a mess.

I remembered my kitchen drawers with some cha-
grin as I gazed at Danny's elegant silverware drawer. I
took out my phone, quick, so he wouldn't see me, and
took a picture.

Looking at the photo now, I see that Danny's sil-
verware organizer was made of wood and filled the
entire drawer, obscuring the metal shelf below. It was
organized into six separate sections. Each section
had a picture of what belonged there carved into the
wood: a fork engraved above the space for forks; a large
spoon for tablespoons; a smooth-edged knife for but-
ter knives; a teaspoon for the small spoons. The two
remaining slots had no pictures—they were designated
free spaces for miscellaneous items. One slot had been
filled with plastic wine stoppers and the other with ser-
rated knives. The organizer was so efficient, everything
so clearly in place, that I was reminded of the severe
elegance of a professional restaurant kitchen, and of the
concept of *mise en place*, the engine behind the French
kitchen and, indeed, the way the French live in their
kitchens.

Mise en place *translates as "to put in place" or*
"everything in its place" and is the most important
principle all French cooks follow in their kitchens.
Simply put, it is the system the French use to put
tools and ingredients where they "belong," but it is
more than just an organizational system. It is a
way of thinking about one's space.

To practice *mise en place* in your kitchen, assign each item in the kitchen a place to live. Make sure it is the most logical and easy-to-get-to home for that item—the measuring cups near the rolling pin, and the baking pans near the oven; the colander near the sink and the silverware drawer below the plates; the olive oil and vinegar near the salad bowls—and then you assiduously, passionately, obsessively observe this order. Easy, right?

I first heard of the concept while watching a Julia Child program on television, long before I lived in

France. She explained that the French restaurant chef would never be able to work so efficiently in the kitchen without the practice of *mise en place,* and although I didn't understand the idea fully at the time, I came to see that she was right: every object in a French kitchen—and to a lesser degree a French home—has a designated place, one that has been created just for that particular object. *By learning the art of mise en place in the kitchen—and in your home in general—you can change the way you live in your home, and thus your life.*

In a French restaurant and a French home, there is no way to overemphasize the strict insistence upon a well-ordered kitchen. I, with my slapdash ways, with my messy "Tupperware drawer" or "miscellaneous drawer," am in awe of this marvel every time I am confronted with it. Sometimes, when I pass a kitchen in France, I sneak in, open a drawer, and behold the perfectly stacked (and ironed!) cloth napkins; the shining silverware—all of the same brand, with the same number of spoons, knives, and forks nested in neat rows; the steak knives, all sharpened and ready. And then there is the glassware: it all matches. Always. Matching red-

wine glasses, white-wine glasses, Champagne glasses. The coffee cups are sometimes odd colors and shapes, but they are the only mismatched items I've found in a French kitchen, and this is usually for sentimental reasons: the teacup bought in London and the espresso cups bought in Rome are, by their very nature, not going to match. Even men like Danny, and women like my French sister-in-law, who live alone and very often eat alone, have kitchens with this level of organization and functionality. It is so precise, so scientific, that it makes one think of a chemist's chart, a kind of periodic table or kitchen taxonomy.

How do they create this kind of order? It isn't magic, but through hard-nosed pruning of objects based on *mise en place*. One asks the simple questions: What tools are necessary and is there a place for them? In the kitchen, where so many small, necessary objects are stored, *mise en place* is essential. I am not an expert organizer (as my mother-in-law would attest), but I've learned from the French that putting everything in its place—*and keeping it there*—is the secret to a harmonious kitchen. Learning the art of *mise en place* will help you achieve this.

THE ART OF *MISE EN PLACE*

❋ **MAKE AN INVENTORY:** Get a notebook specifically for your kitchen and make a list of every item, no matter how small it may be: coffee makers, corkscrews, flour sifters, meat thermometer, etc.

❋ **DETERMINE FUNCTIONALITY:** Twenty-seven water glasses? Do you ever have that many guests? Pare it down to ten or twelve, and match that for all glassware. Three soup spoons? That is clearly not enough, so buy more.

❋ **CREATE UNIFORMITY:** Do you have twenty different colors of dish towels (like me)? Throw them out and splurge on new ones that are all the same color and size. Cultivate a rigid uniformity in your glassware and dishes: make sure they are all the same color, brand, and style. If your plates are yellow, your bowls should be, too.

❋ **CHOOSE WISELY:** Consciously create a permanent home for your kitchen tools. Analyze the space and

decide what drawer or cabinet is most efficient for that object's purpose. Knives are stored near your chopping area. Spatulas and wooden spoons (and saucepans and frying pans) near the stove. For a perfect example of this, look up on the Internet Julia Child's infamous Peg-Board, which held her many cooking tools.

❋ **MAKE LABELS:** If you've decided the food processor lives on the shelf under the counter, write FOOD PROCESSOR on a small label and stick it on that space. It sounds a little extreme, but it will work. The more you are reminded, the more likely you will be to maintain order. I know a woman who used this method when she learned Russian, writing the word for *oven* and *spoon* and *refrigerator* in Russian on labels and placing them all over her kitchen. For a month, her kitchen was filled with Russian until she knew the words well enough to remove the labels. Try this with your kitchen . . . and maybe learn French in the process!

❋ **ASSIDUOUSLY, PASSIONATELY, AND OBSESSIVELY OBSERVE THIS ORDER:** When you use something

while cooking, clean it and put it back where it belongs. Break a glass? Replace it immediately. The only way to maintain *mise en place* is simply that, maintain it.

After you've put your kitchen in order, *practice mise en place as a daily ritual,* one that is as regular as coffee in the morning or brushing your teeth before bed. When you take out a knife to chop onions, use it for its purpose, and then *immediately wash it and put it back in its place.* Don't throw it in the sink or leave it on the chopping board. It has served its purpose. Now reward it and take it back home.

I have watched French families and friends follow this practice meticulously—they will use a kitchen tool, then immediately clean it and put it away. It's part of the rhythm of cooking. This practice makes the cooking experience much more fluid and efficient. While it may seem a bit obsessive in the beginning, it eventually becomes second nature. Putting things in order as you go keeps your kitchen from getting messy and chaotic while you work. It ensures that you won't lose track of

your tools, or lose time when you find yourself in an overwhelming mess. When this happens, as it will from time to time, stop and return everything to its place. If you find that your system has gone off the rails— you've accumulated more kitchen gear or broken some wineglasses—you can always reset. Go back to the beginning: grab your kitchen notebook, assess the objects you own and use, add and subtract items, and give them permanent homes.

Note that the French own stuff, sometimes a lot of it. They do not live in a minimalist environment with no possessions. Theirs is an heirloom culture, one that values the acquisition of beautiful, precious objects and the preservation of them for the next generation. Throwing out grandma's silver cutlery is not an option. By necessity, they have created a system to keep everything in order. In fact, French children are taught *mise en place* with their belongings—both at school and at home. When my daughter was five, for example, she learned to put her pencils and pens in a certain order in her desk, and then arrange her paper and scissors in one place, and put her *cahiers* in the order of that day's schedule. Finding some-

thing out of its place is a very serious issue for French children—they are scolded for being disorganized much more than I was as a child—and so they learn to get things in order pretty fast.

The kitchen is also used for storing food, and the French approach this, and the purchasing of food, very differently than we do. Before the large supermarket chains like Carrefour and Super U and Picard popped up in every town in France, there was no choice but to go food shopping every day. And while it is now possible to stock the pantry full with supplies weekly—buying milk, bottled water, cream, butter, and dry goods in bulk—most French people still prefer to shop the way they have for centuries: buying small amounts of fresh food from locally owned neighborhood stores several times a week, and bread from the bakery every day. In this system, you buy less food, consume it fresh, and waste very little. Food storage is more transitory in a French kitchen, less an act of digging in and holding on to supplies for weeks or months than a momentary rest in the fridge before

ending up on the table. *The French protocol for food storage is circulation. Food goes in and is eaten the same day. There's no time to linger. Buy fresh and eat fresh.*

Le frigo, or refrigerator, reflects this philosophy. The French refrigerator is much smaller than our American fridges. In fact, the French call large, double-door refrigerators "American," and it has become *à la mode* (and expensive) to buy a big fat American *frigo* equipped with a water dispenser and an ice maker. I admit that when I first moved to France, I had a hard time adapting to the refrigerator. My house was equipped with a narrow French fridge, and my first urge was to buy a big one. But I soon came to understand that the small size is well suited to the French diet: there's no room for overconsumption and waste. When it comes to food, *the French buy what they need, and use every last scrap of it.*

This was an enormous lesson to me. We Americans stockpile food, as if the apocalypse were nigh. When I was growing up, my family went grocery shopping on Saturday and bought enough food to last the entire week. There were bags and bags of dried, canned, frozen, and boxed food stored in our kitchen. Sometimes we

shopped at stores that sold items in bulk at discounted prices—Walmart, Sam's Club, Costco, and so on. But while there is a growing tendency toward this kind of bulk shopping in France—there is a food warehouse called Metro that made my American shopping instincts go into overdrive—the general practice is the opposite. The baguette, for example, is baked daily, and in many bakeries, twice daily. My husband claims that a baguette is stale after six hours out of the oven. Having food that is fresh is more important than food that is convenient, and the French *cuisine* reflects this. The French do not fill their refrigerators and pantries to the point of bursting. When I look into a French refrigerator, I see a lot of empty space.

Unfortunately, my experience of poking around in people's refrigerators and pantries has been more limited than my other home explorations—it isn't easy to get into a French person's kitchen, let alone the refrigerator!—but when I was able to take a look, I always found certain items in a French pantry: *confiture* (jam), yellow Dijon mustard, high-quality olive oil, cornichons (small pickles), honey, nuts, high-quality choc-

olate (often for baking), dried fruit, coffee, a bouquet garni (a bundle of rosemary, bay leaf, thyme, parsley), sea salt, and vinegar.

One evening over dinner, I brought the French pantry, known as the *garde-manger*, up with Marie, a French filmmaker who specializes in photographing food. She told me that in the past, the *garde-manger* was a cabinet or closet that opened to the exterior of the house, keeping butter and milk from spoiling (I imagine it must have been locked from the inside, to avoid theft). In large homes or castles, cold storage for dairy and meat was on the lower level of the home, sometimes in the basement, and was overseen by the cook and kitchen help. The *garde-manger* was usually locked, and he or she who held the key had great power over the household.

Marie said that the one thing that unites French people of all classes is what you'll find in the pantry: no matter how rich, or how poor, you will always find cornichon pickles, vinegars, olive oil, cheese, butter, and jam. Nothing, neither class, region, nor education, can change this common culinary cohesion.

Butter is another staple of the French pantry and is always stored in a covered dish called a *beurrier* and not simply wrapped up in the paper or foil. I learned this lesson the hard way. After I left the Airbnb apartment I rented in the 12th *arrondissement*, I received a photo of the block of butter, wrapped in its gold foil, that I'd left in the fridge. It was 99 percent unused, and so I had wrapped it up and it left on the shelf, believing it would be used when the owner returned. He wasn't pleased. He complained that I had left a mess in his fridge. Why? *Because the butter was uncovered!*

Clearly, the French are finicky about food storage. But they have reason to be: their kitchen system—from shopping to storage to cooking to eating—has paid off. French eating habits have produced healthier people. The French are ranked twenty-third in the world for obesity (Americans are ranked first) and ranked four-teenth in the world for life expectancy (compared to Americans' fortieth position). The way they eat has given them slimmer, longer lives.

Much has been written about French eating habits,

especially the "French paradox," the idea that French people consume rich, fattening foods like cheese and pâté, drink wine every day, and still stay healthy, thin, and live to one hundred years old. While many may try to emulate the French diet—drinking red wine and eating Brie cheese every day—I don't think French food *per se* is the source of this paradox. *The secret lies in the way the French live with their food, the way they buy, store, prepare, and eat their food.* From the wicker shopping basket, to the pantry, through the rigors of the *cuisine* and to the *salle à manger*—this system dictates that we eat fresh food daily, in smaller quantities, with friends or family. The very act of eating in a group, and participating in meaningful conversation, slows one down, makes smaller portions sufficient, and discourages overeating. The French understand this deeply and hold tight to their traditions around food, even when they are not in France. My French friends in New York are religious about going to farmers' markets. They buy bread fresh from the bakery as often as possible. They make quick, uncomplicated shopping

part of their daily routine. They buy small amounts of fresh food each day, eat all of what they've made, and save nothing.

But old habits are hard to break—indeed, I am continually overstocking our fridge and pantry, even after years of trying to limit food shopping to daily needs. My husband finds it baffling. *Why buy a case of yogurt? We can get more tomorrow.* To check this habit, I clean out the fridge often and use whatever is in the fridge for dinner that night. I've found that emptying storage spaces in my kitchen is essential. For me, an empty refrigerator is an exercise in clearing the mind.

STOCK YOUR FRENCH PANTRY

After living with a Frenchman, there are certain items I like to have on hand at all times.

1. Traditional French mustard. Maille is the most widely known brand. There are different varieties, but finely milled yellow mustard is the classic.

2. High-quality baking chocolate. You can use this to make any number of quick desserts, but my favorite is the delicious and easy Fondant au Chocolat, or molten chocolate cake, taught to me by Charlotte, my neighbor in the south of France (see recipe below).

3. Cornichon pickles. These pinkie-size pickles are eaten with salads, as a side with chicken or beef, and, of course, with burgers.

4. Olive oil. I used to buy fresh-pressed olive oil from an olive press near my home in the south of France. The farmer would deliver a five-liter *bidon* to my door every six months or so. Now I buy Italian extra-virgin olive oil whose quality (and authenticity) I am able to verify online.

5. Vinegar. There are many varieties, but I most often find red wine vinegar, balsamic vinegar, or Champagne vinegar in French pantries.

6. Sea salt or *fleur de sel*. While living in the south of France, I came to love salt from the Camargue region. *Camargues* means "swamp" in French, and the salt

from this area has an earthy, briny flavor. Salt from Brittany or Normandy is equally delicious.

7. *Confiture*, or jam, preferably homemade and without added sugars or artificial flavors. Bonne Maman jam is available almost everywhere, and is made and shipped from France, which ensures that it has the same composition of sugar (that is, no corn syrup) and non-GMO fruit as in France.

8. *Herbes de Provence*. This herb mix was available everywhere when I lived in France. It contains rosemary, fennel seed, oregano, bay leaf, and other herbs. I use it for everything from soups and sauces to roast chicken. If you cannot find it premixed, take a look online for a recipe to make your own.

9. Honey. Another treasure of the south of France, honey replaces sugar for many French people. It is added to plain yogurt or even to coffee.

10. Flour, sugar, and bouillon cubes. In fact, Knorr has developed a line of plastic pouches that contain bouil-

lon jelly. The French use them in soups and other dishes. These are available in the U.S., and in many other countries. I love these, and use them to add depth to homemade bouillon.

11. Bottled sparkling water.

A note on French kitchen décor. The French *cuisine* is seen as a work space, and the décor tends to be quite minimal and always functional. The idea of a themed *cuisine*—with wallpaper and fancy curtains or blinds and pictures on the walls—is not common. In fact, the idea we have of a French kitchen often has more to do with design elements than functional ones. Go online and search for "French kitchen" and you will most likely find a series of expensive, highly decorated, fussy kitchens with islands and chandeliers. I have never seen a crystal chandelier in a French kitchen (not even in Versailles!), and the French wouldn't dream of decorating that way. The beauty of the French kitchen rests in its elegant functionality.

CHARLOTTE'S
FONDANT AU CHOCOLAT

When I lived in the south of France, my neighbor gave me her recipe for Fondant au Chocolat, a chocolate cake with a spongy exterior and a molten, liquid center. I have made this dessert a hundred times at least, and it is one of the easiest, quickest, and most universally loved. You can use small ceramic ramekins (mine are 8-ounce Le Creuset ramekins) to bake individual fondants, or you can use the larger, classic quart-size soufflé dish. The below recipe makes six individual cakes. The soufflé dish will serve five to six. I always have the ingredients for this dessert on hand in my pantry, just in case I crave chocolate, which happens often.

I've listed both French and U.S. measurements for convenience.

Ingredients:
 5 large eggs
 Butter, 200 grams or about 1¼ sticks
 Sugar, 200 grams or about 1 cup (This can be reduced to 150 grams or ¾ cup)

Dark chocolate, 70% cocoa, 200 grams or about
1 cup. You can use baking chocolate or, if you want
an over-the-top rich chocolate cake, high-quality
dark chocolate.
Flour, 1 large, heaping tablespoon

Preheat the oven to 200 degrees C or 390 degrees F.
Break the five eggs into a mixing bowl and whip them
with a whisk. Melt the butter, sugar, and dark choco-
late together in a heavy-bottomed pot over a low flame.
When everything is melted, add one heaping tablespoon
of flour. Mix until creamy. Using a rubber spatula, add
the melted chocolate mixture to the eggs, and stir with a
whisk or a hand blender until it becomes the consistency
of pudding. Transfer into ramekins (filling about half-
way) or soufflé dish and put in the oven for 22 minutes.
Note, for the ramekins, cooking time reduces to about
15-18 minutes, depending on your oven. Check after
15 minutes to make sure that the outside of your fondant
is hard, and liquid at the center. Serve hot with crème
fraîche or vanilla ice cream, if desired.

LE PARFAIT JAR:
THE POWER OF NOSTALGIA

During Napoleon's rule, there was a nationwide hunt for a method to transport preserved food to soldiers. A contest with a cash prize was announced, and in 1810 Nicolas Appert won by developing what we now call canning: sealing fresh food in an airtight glass jar and boiling off the bacteria. *Le parfait* jar—the classic French canning jar we've all seen on our grandmothers' shelves, the glass jar with the orange ring and the metal clasp—became popular later for canning, and while tin cans and other forms of food preservation have replaced the glass *le parfait*, which means "perfect" in French, there is a deep nostalgia in France for the idea of old-fashioned, natural food storage, especially the kind that implies the preservation of market-fresh fruit and vegetables in glass jars. Unless you are living on a farm and have infinite time on your hands to grow, harvest, and store your own food, canning is unpractical in the modern world. Virtually no French person I know actually preserves their own

food. And yet there is a yearning for the old ways when it comes to the production and storage of food. Bonne Maman jam, available internationally, plays on this nostalgia by using a glass jar and a red-and-white-checked metal cap. I've found mini *le parfait* jars containing jam, *haricots verts* (green beans), and pâté. A jar or two of anything homemade—or with the appearance of being homemade—is always welcome in France.

French *Cuisine*

1. Your kitchen is a work space. Remove everything that isn't meant for supporting the work of cooking.

2. Your kitchen and your tools must be in working order: repair or replace anything that breaks. Sharpen knives. Replace missing measuring cups. Throw out old tea towels and ripped rags.

3. Your cupboards require taxonomy. Organize glasses by type, brand, size, and function, and have the same number of each type. Do the same with dishes.

4. Your drawers should be orderly: institute extreme organization of your kitchen drawers. Create a simple, clean system for organizing storage

containers, kitchen utensils, and napkins, and remove all items that don't serve you. Be relentless.

5. Embrace emptiness in your refrigerator: buy fresh food and ingredients as needed instead of buying in bulk and creating possibilities for waste.

6. Your pantry should always have these essentials: olive oil, jam, mustard, pickles. Keep your pantry stocked as the French do. Or, if you have your favorite items, always keep a small supply on hand.

7. Your guiding principle is *mise en place*. The ritual of putting everything in its place is the engine of your kitchen. Assign every object a place. And keep it there.

5

La Laverie

The most famous French Laundry in the world is not actually a *laverie* at all, but a three-star restaurant in California housed in a defunct French steam laundry. Hundreds of years before the restaurant existed, the French way of doing laundry—by hand, with hand finishing and technologically advanced stain removal—was considered a superior way to clean clothes. And though the restaurant inherited its name with the building, and traditional French laundering has nothing to

do with what's going on in that restaurant's kitchen, I think the name works particularly well. The image of a French laundry calls to mind something deeply sensual and seductive: the crisp, white linens of a dinner table, the smell of fresh-pressed cotton, the softness of a warm *serviette* against the lips. It speaks of the good things in life: the beautiful, the orderly, and the luxurious.

Those are not the sensations that usually come to mind when I'm doing the laundry. I have always disliked this chore. If there was one area of my home you would be least likely to find me, it was the laundry room. Of course, clean clothes are a necessity of life, and so I did my laundry like everyone else: I would gather up dirty clothes in a basket and carry them to the washing machine, where I'd toss them inside, pour in some detergent, punch a button or two, and get out as soon as possible. I knew all the basics: separate the whites from the colors; use cold water to keep dyes from bleeding; and never dry clothes on "high heat," or they would shrink. I also just accepted that socks always got lost, that T-shirts would usually be wrinkled, and that bedsheets were impossible to fold.

I was not a fan of ironing, either. I often bought clothes that wouldn't need to be ironed, just to avoid the task. When a shirt came out of the dryer wrinkled, I would smooth it out as best I could and live with the result. I did the laundry only because it was absolutely necessary, without joy or technical knowledge of the task at hand.

It wasn't until after meeting my French mother-in-law that I understood that there is another way of thinking about the laundry. Her *laverie*, or laundry room, like many I have seen in France, is simple, stream-lined, and no-nonsense. Like the kitchen and bathroom, it is a highly technical space, one whose sole purpose is to get the job done. My mother-in-law's *laverie* is tucked into an alcove off the kitchen. There is just enough room for a front-loading washer/dryer; a long countertop for folding clothes; cabinets for laundry soaps, stain removers, starch, fabric softeners, and other products; and a large, imposing steam iron. Above, tied up to the ceiling with a rope, is a heavy iron drying rack. Unlatch the rope and it can be lowered down on a pulley. Pull it, and it ascends overhead, out of sight.

The *laverie* is not a historically traditional room in a French home, as it wasn't until the twentieth century that the washing machine became part of modern life. Before then, there were public *lavoirs*, or washhouses, where women took the household laundry. According to Mireille Roddier in her study of *lavoirs*, these washhouses were exclusively for the rich (or the servants of the rich to be precise) before the Revolution, and then became a place for village women to do their laundry. They used washboards to scrub the clothes, and bat-like sticks to pound out the water. When I lived in the south of France, there was an old public *lavoir* positioned over a stream just outside our village. When I walked by, I would stop and imagine how, only decades ago, before running water and modern appliances made doing laundry a private activity, groups of women would go to the *lavoir* together. I imagined how they would have exchanged information, discussed village happenings, and offered advice to each other about their homes, their children, their husbands. Laundry was once a social activity. But now it is something we squeeze between other activities of our day.

As time went by, the French developed other methods of cleaning their clothes. There were various mechanical contraptions for washing and wringing out water, as well as coal-heated flat irons to smooth wrinkles. Plant-based soaps from Marseilles—made from olive, coconut, and palm oils—became highly coveted and were exported throughout the world. Jean Baptiste Jolly, a Frenchman, discovered and developed dry cleaning when he spilled kerosene on a dirty tablecloth and found that the stains disappeared. The 1912 book *The Secret and Science of French Dry Cleaning,* which introduced an American audience to the techniques of dry cleaning at home, cites M. Judlin as popularizing dry cleaning in 1866. The book suggests that Americans could dry-clean their clothes at home in a large metal milk can. It gives advice about cleaning everything from gloves to top hats to furs, and discusses the chemicals used in the process—gasoline, turpentine, and borax, to name a few. I had never considered laundry a risky endeavor, but home dry cleaning seems dangerous. My favorite bit of advice about home dry cleaning? *"Never use gasoline near a flamer or fire of any kind, as it is very 'explosive' and*

'*dangerous.*'" There's a reason dry cleaning is now left to the professionals.

The original French laundry (as opposed to the Chinese laundry or American laundry) was distinguished by the French tradition of hand finishing—washing, drying, ironing, starching, and mending by hand. This practice is extremely labor intensive. I recently discovered a New York City French hand-laundry service, Allo Laverie, that uses only traditional French techniques to clean clothes. According to their website, they use plant-based detergents that preserve the fibers of antique fabrics. Their site claims that in the seventeenth century, French aristocrats sent their laundry to the Caribbean to be laundered—clearly the labor was more readily available in the colonies. Allo Laverie's drying methods can take three days, as it does with a feather down comforter, which is hand shaped and air dried. Such laborious methods are expensive. How much does it cost to wash a bedsheet? Twenty dollars. A quilt? Fifty dollars. Seventy-five if it is vintage.

I don't know many people (French or otherwise) willing to pay those kinds of prices for clean sheets, no

matter how soft. None of my French relatives would even consider it. My parents-in-law are generous people— they throw some of the best parties I've attended in France, and they are always the first to give gifts—but they abhor waste. The French appreciate and respect luxury, but they value thrift even more, and a French home reflects this. During my time in France, I observed that the French use everything. Leftovers in the fridge? They make a casserole. A centimeter of shampoo? They squeeze it out. They are thrifty with electricity, water, and heating as well. This doesn't have to do with money. The wealthy are (so far as I have seen) as careful as anyone else. The value of thrift is a lifestyle choice. It is not a question of money as much as a question of respect for the energy of the home. I will never forget the day Jacqueline, who loved a bargain more than anyone on earth, found dozens of nineteenth-century hand-embroidered napkins at the Salvation Army for fifty cents each. "It is an art," she said, her eyes lighting up with triumph, "to spend like a miser and live like a queen."

A note on embroidered napkins, antique tablecloths, and other seemingly old-fashioned linens: they are a lux-

ury worth hunting for. After my marriage, my mother-in-law gave me a set of white linen napkins that had been hand embroidered with the family initials: *PV*. These had been passed down for generations, and yet they—and the matching tablecloth—were pure white, as if they had never been used, which is a testament to the Postel-Vinay laundry skills. Since then, I've taken to going to *les brocantes* or *les puces* (street markets and flea markets) when I am in France, looking for old French linens. Beautiful linens were coveted in the United States, as well as in France, and you can (like Jacqueline) find them at a bargain price if you go hunting for them.

If you're not the antiquing type, or you'd like to have personalized monograms on your table linens, there are a few easy options. One is to find a seamstress in your area who can monogram your tablecloths, napkins, etc. Or there are a number of mail-in services that I've found by doing a search online. Stores like L.L.Bean will monogram your purchase and mail it to you directly. It's easy enough to have monogrammed linens and towels, and yet it is something I rarely see in the American home.

Take one look at my mother-in-law's *laverie*, and you'll understand that laundry is a serious subject for Madame Postel-Vinay. I once opened a cabinet in her laundry area and saw a dozen small bottles standing together on a shelf, each with a different colored label, arranged together like spices in a rack. Examining the bottles, I saw pictures of chocolate, blood, oil, rust, ketchup, and ink. These, I realized, were customized stain removers, or *détachants*. I was amazed. Why on earth did she need so many kinds of *détachants*? In the States, there was just one general stain remover spray, so far as I was aware. When I asked my mother-in-law about her stock of products, she acted as if it were the most obvious thing in the world to treat different stains with different chemicals. And, of course, looking at it from a scientific point of view—which is precisely how the French view laundry—this makes perfect sense. Grass stains are not the same problem as ballpoint pen ink, and olive oil is utterly different on a silk blouse than coffee. *How could one expect to remove all these different stains with the same chemical?*

Later, walking through a large Carrefour supermarket near my home in the south of France, I decided to investigate. To my amazement, I found an entire wall full of bottles of *détachants*, a rainbow of colored labels. They were inexpensive—a euro or two for a bottle—and so I bought a few, one for blood, another for grass stains, and another for oil and grease. My kids were always coming home from school with grass-stained jeans, and while I preferred to sleep on white cotton sheets, I was afraid to use them when I had my period, as blood is always difficult to wash out. If I could save one pair of jeans, or a few sheets, I would pay for my stain removers ten times over. I decided to give them a try.

A month later, I had twenty different small bottles in my laundry room, my own spice rack of stain removers. What surprised me the most was the pleasure I took from saving my clothes from ruin. I had never realized how frustrating it was, living at the mercy of stains. I used my stain removers assiduously when I was in France and was prepared to say goodbye when we moved to the States. Honestly, I was amazed that I had come to care, actually and truly care, about the state of my laundry.

A revolution had taken place, one that I attributed to a slow, subtle French influence: I enjoyed doing the laundry because I had learned to do it well.

When we moved to New York, I packed a set of stain removers. I didn't think it would be possible to find such specialized products back home, and I would once again be using one *détachant* for all stain problems. Recently I found a European-owned brand called Carbona (www.carbona.com) with a full range of stain removers. Carbona has had a presence in the United States since 1908 and was one of the first companies to offer nonflammable cleaning solvents. They sell a "Stain Devils System," a set of nine bottles of small stain removers like the ones I used in France: Rust & Perspiration; Coffee, Tea, Wine & Juice; Motor Oil, Tar & Lubricant; Grass, Dirt & Makeup; Fat & Cooking Oil; Ink, Marker & Crayon; Chocolate, Ketchup & Mustard; Nail Polish, Glue & Gum; Blood, Dairy & Ice Cream. I set up my stain remover spice rack across the Atlantic, and my French *laverie* was off and running.

That said, all the *détachant* in the world isn't going to help you achieve a proper French laundry if you don't have your laundry method down correctly. I found,

when I did my laundry with my mother-in-law, that she follows strict rules in the washing of their clothes. As it turned out, my method of separating colors and whites and using one kind of detergent was not quite specific enough. Madame Postel-Vinay learned her method from her mother, and she continues to use it today, even after technology has changed.

First, she searches each item of clothing, looking for items left in the pockets. She has found gum, pens, and money, among other items, which would have created problems if they had gone through the wash. After clearing the pockets, she treats the stains. Then she sorts the items by color and fabric, choosing the correct temperature for each garment. Washing clothes of similar color and fabric in small batches is preferable to throwing them all in at once (the way I had always done). And while she owns a clothes dryer, she tries not to use it unless absolutely necessary. She air-dries her clothes as often as possible. When there is a small amount of laundry, she hangs it on the metal rack and hoists it up to the ceiling. In the summer, when she is at her country home in Brittany, and it isn't raining, she hangs the laundry

outside to dry on the line. I remember her surprise when I told her that I always use an electric clothes dryer. She sees this as a waste of electricity (and thus money), but even more important, it is bad for the clothes. An electric dryer will fade, shrink, and deteriorate whatever you put inside it.

Tumble drying and the clothes dryer, or *sèche-linge*, in general is a hot topic in France. By far the most debated subject about laundry in the online forum I read (on aufeminin.com) is whether one should own a clothes dryer at all. Modern French women—most of the people on that forum are younger women—by and large love their *sèche-linge* and vote yes for owning one. Of course, in the United States, this isn't even a question. We all use clothes dryers. Even in the summer, when the weather is beautiful, most people continue to use them.

At my home in the south of France, where the weather was beautiful much of the year, it made sense to hang clothes outside to dry. I strung up a line in the yard, attaching one end to a Provençal-blue shutter and the other to a hook bored into a wall, just above my herb garden. I pinned jeans and dresses and underwear up to bake in the

sun, and hours later, when I pulled my clothes down, they smelled of fresh air and rosemary.

With air-drying comes my *bête noir*: ironing. I don't think I'm the only person who feels uneasy when she sees a long, flat board on metal legs. My generation of women—and the generation before my generation, in fact—found ways around starching and steaming our clothes. Avoidance, as I mentioned earlier, works wonders. Delegation also helps. You know you've made it when you can hire someone to help you iron your clothes. After years of ironing her family's clothes, my mother-in-law put Betty, their regular cleaner, on ironing duty. On the days when Betty is at the Postel-Vinay home, one can find her in the *laverie*, the stacks of ironing piling up on the counter. Everything is ironed: from dress shirts to boxers to napkins to jeans. Once, Betty ironed an outfit for me. When I slipped into a warm, crisp pair of Levi's, I understood that the ultimate luxury is a pair of ironed jeans. I was almost tempted to start ironing my own. Almost.

MADAME POSTEL-VINAY'S
STEPS TO PERFECT LAUNDRY

* First, empty all pockets.

* Do a stain search. Be thorough. Check all collars and armholes for discoloration.

* Treat stains with appropriate stain remover.

* Turn garments inside out.

* Always sort your clothes before washing them:
 * Linen washed alone
 * White cotton alone
 * Colored cottons alone
 * Colored synthetics alone
 * Woolen garments are hand washed and laid flat on a cloth to dry

* Iron everything: jeans, napkins, even sheets.

Of course, the most assiduous ironing job in the world will be useless without *proper folding techniques.*

There are many ways to fold a towel, and I understand there is great debate in families about what, exactly, the correct format entails. I admit, for years and years, I simply folded my towels however the mood struck me: sometimes in half, then in half again. Sometimes in thirds. Sometimes I even rolled them up like little sleeping bags. I believe my mother tried to train me to fold towels with some semblance of form, but I never quite got it. In college, I sometimes just left my towels in the laundry basket until I needed one.

Similarly, there is no single way to fold a towel in France. I've watched YouTube videos promoting all variety of towel folding, and they are very often contradictory. Madame Postel-Vinay, however, folds her *serviettes*—napkins, tea towels, bath towels—in thirds. I've noticed, when I reach for a towel in the Postel-Vinay *salle de bain*, that they are always exactly the same size, the same color, and stacked with a crisp, military-grade order. The trick is to choose your fold and stick with it.

Bedsheets are another matter.

French bedding consists of a fitted sheet that covers the mattress and a duvet cover (an envelope or pocket

sheet that covers a blanket or comforter and snaps shut to fully enclose the blanket inside, effectively replacing the American top sheet and protecting the blanket from stains). These can be unwieldy, especially the big ones. I'll never forgot how once, when my husband and I were doing the laundry together, he watched me struggle to fold a queen-size fitted bedsheet. I was trying to manipulate it into a square, but it ended up looking like a *croissant*. A look of utter perplexity fixed upon his handsome face, and he took the sheet off my hands and showed me the correct way (i.e., the French way) to fold it. In thirty seconds, the fitted bedsheet sat in a perfect, tight square, or *carré*. I stood, mouth agape, a little awed by this show of *savoir faire*. He had learned this incredible skill from his mother years before. I'm not the quickest study when it comes to laundry, and although he showed me the trick a few times, and I went through the motions, I had to watch a tutorial online to fully understand the method. Google "*Comment plier un drap-housse*" (how to fold a bedsheet) to look for helpful videos. It might take practice, but soon you will have perfect French bedsheet *carrés*.

THE PERFECT BEDSHEET *CARRÉ*

❋ **STEP ONE:** Hold your fitted sheet in both hands with the top side facing you. Put your left hand into the corner of the sheet so that the corner seam lies flat across your hand (the seam is facing out).

❋ **STEP TWO:** With your right hand, do the same with the other corner. You will now have both arms extended, and each hand holding one corner.

❋ **STEP THREE:** Here's the magic. You match up the two corners so that the seams make one straight line. Then you flip the right corner over the left corner. You are now holding both corners (one tucked into the other) in your left hand.

❋ **STEP FOUR:** Grab the third corner with your right hand (making sure the seam faces up), and tuck this corner *under* or *inside* the left corner. Now you have three corners in your left hand.

✻ **STEP FIVE:** Grab the last corner with your right hand and tuck that one into the left corner. Now all four corners are neatly tucked into one corner. To make sure you've done this correctly, check that the seams all line up, all stacking up, one on top of the other.

✻ **STEP SIX:** Place this square down onto a flat surface. If the sides are uneven, fold them so that you have a square. Fold this square four times, so you have a long thin rectangle. Then fold this rectangle three times. *Voilà.*

My father-in-law once told me an old French saying: *Ne pas mélanger les torchons avec les serviettes,* which essentially means: Don't mix the dishrags with the linen napkins. I'm sure this is some sort of old-fashioned warning about mixing with the wrong kind of people, but I like to think of it literally. When it comes to laundry, don't mix things up. Find a method for your *laverie* and stick with it. And maybe, by doing your laundry the French way, it will feel less like a chore and more like an act of pleasure.

French *Laverie*

* Find the ideal spot for your *laverie,* one that is convenient but not in the middle of the action of your home. The French often choose to put their laundry room near the kitchen, but I've seen washing machines in the bathroom, or in a closet. A well-situated, organized *laverie* makes laundry less daunting.

* Substitute natural, traditional products for harsh chemical ones. White vinegar, soap from Marseilles, and homemade detergents work just as well and are much cheaper than the organic products available in supermarkets.

* Create a stain remover toolbox.

* Develop your folding technique for towels, sheets, and blankets so that your storage areas will be neat and orderly.

* Mending is easier when you have everything in one place. Make a sewing kit and keep it in your *laverie*.

* Embrace air-drying and clothesline drying—it saves money and your clothes.

6

La Salle de Bain
and *La Toilette*

Unless you are a long-term houseguest in a French home, you may never actually see the bathroom. It is a private room and is often on the other side of the house, tucked back by the bedrooms. The traditional French *salle de bain* does not contain a toilet. For that, you'll be directed to another room, one no bigger than a small closet—I always think of the British term "water

closet," which has nothing to do with the room where bathing actually occurs.

In my opinion, you aren't missing much. I am not passionate about French bathrooms the way I am about the *salle à manger* or the *cuisine*. I feel no sense of happiness or kinship to the space, no particular communion with French culture and history, as I do in the *salon*. In fact, every other room of a French home has a particularly French ambiance. But the *salle de bain* has, over time, adopted so many elements from British and American bathrooms that the original flavor has disappeared. The French *salle de bain* lost its soul.

Like French kitchens, the French bathroom is a technical space, usually unadorned, often hospital white, and always as clean as a clinic. If it sounds a bit severe, well, it is. There is very little pleasure to be found in the French bathroom. I like to spend hours in a hot bath, soaking, reading, listening to music, contemplating life. I like to refill the bath a few times, to keep the water hot. I sometimes even drink a glass of wine while bathing, which would probably horrify the French. Most French *salle de bains* are simply not set up for such luxurious, spend-

thrift rituals. They are too practical. They have none of the earthy spirituality of a Japanese bath, for example, or the sensuality of an Italian bath. Even large, designer bathrooms in France feel a bit meager. It is as if you're meant to do what is hygienic—wash, brush your teeth, shave—as quickly as possible and get to the *salle à manger*, where the real fun begins.

Perhaps French indifference to the *salle de bain* is because, historically, there hasn't been much of a bathing culture in France. It has only been a few hundred years since the French started to bathe with any regularity. Louis XIV was terrified of the bath—at the time, water was believed to cause disease—and claimed to have bathed only three times in his life. By 1900 only 4 percent of French homes had a bathtub. Unlike the Romans, who developed mechanisms for running water thousands of years earlier, the French didn't have fully working indoor plumbing until the nineteenth century. In the country, people would only bathe around four times a year. In cities, where different standards of hygiene were developing, a mobile bath called *une baignoire ambulante* would be pulled through the streets, stopping

door-to-door, selling bath time. You would pay a fee, the tub would be filled with hot water, you would climb up a narrow ladder, slip in, and scrub away the weeks' worth of filth. It was the Uber of bathing.

By the nineteenth century, the French perception of bathing had changed. This shift was in part influenced by the British, who had been promoting bathing as a cure for various illnesses throughout the Victorian era, and by the fact that many of the old superstitions about water and disease had been cleared away by science. The wealthy installed bathrooms that were more like a *salon* or *boudoir* (see chapter 10). These rooms were part of the bedroom, or at least close at hand, making them part of the private chambers of the family. Many things happened at once in these protobathrooms—dressing, bathing, and socializing. Often *coffres*, then *armoires*, or wardrobes, were installed here so that clean clothes were available after bathing. With carpets, tapestries, and artwork, these rooms were more sumptuous than French modern bathrooms. Tubs and bathing basins were sometimes hidden under sheets or covers, or hidden in large *armoires*. There were no porcelain tiles, because

there was no running water to splash around. What we consider to be a simple, everyday act of hygiene was an incredibly difficult task at this time. One had to carry the water, bucket by bucket, into the home, heating it on a fire or stove, and manually fill a bathtub or basin in order to wash. Imagine then emptying the dirty water, bucket by bucket, and disposing of it. Even if you were lucky enough to have a servant to fill your tub, imagine how cold you would be in the winter, when even a wood-burning stove or fire couldn't adequately warm the air, and the water turned icy cold before you finished. Consider all this and be thankful for our running water, hot and cold, and the ease with which most of us can bathe every day.

The modern French bathroom is at odds with the rest of the French *maison* because it is largely imported. The British zeal toward bathing inspired the French throughout the nineteenth century, and the British even began selling new products like shampoo to the French, who were skeptical and dismissive of getting their hair wet. Like the modern French kitchen, the appliances of the French bathroom were largely influenced by Ameri-

can bathrooms of the twentieth century. In 1900, when American bathrooms were displayed at *l'exposition de l'hygiène* in Paris, many French people were shocked by what they called "washing factories." It must not have bothered them too much, because by the 1950s they had converted to American-style bathrooms, complete with shower stalls and white porcelain tiles. Whatever semblance of the traditional bathroom that was left was thrown aside.

It was in the nineteenth century, when French bathrooms were still more uniquely French, that the most wonderful components of the French bathroom arrived on the scene. My favorite is *le bidet*. The *bidet* was a small porcelain basin, often framed by a wooden table, used for washing the *derrière*. Although no one knows for certain who invented the *bidet*, the word *bidet* came into the French language in the early eighteenth century and was most likely derived from the French *bourdaloue*, a useful little porcelain basin in which women peed during long trips in the *calèche* or interminable church services. During a service, women would pass it down the aisle, relieving themselves discreetly, under their skirts, rather than

standing and disturbing the devout. Later, the mechanized, porcelain *bidet* became part of French bathrooms for a large part of the twentieth century. And while they are still popular in Italy and Spain and Japan—some of the best *bidets* in the world are the automatic *bidet* toilets made by the Japanese company Toto—they are becoming less common in France.

In my opinion, this is a pity. In fact, the *bidet* is one of the most ingenious contributions—and one of the few original inventions—that the French have made to the bathroom. I urge you to do what you can to get one. Using a *bidet* leaves you cleaner than toilet paper and can act as a quick substitute for a shower. It is especially useful for women who are menstruating, when it isn't practical to shower more than once a day. And, as anyone who has read a Henry Miller novel can attest, the use of the *bidet* before and after sex used to be *de rigueur* in Paris.

If you are building or remodeling your bathroom, you should install a *bidet* next to the toilet. If your bathroom doesn't allow for expansion, and you can afford a new toilet, get a Japanese model. I have a friend who

bought a deluxe Japanese toilet that has multiple water temperatures, water pressures, and a seat-warming feature. Cold winter morning? Your bottom will never feel the frisson of chill. These toilets are expensive, so if this isn't an option, then there are many less expensive *bidet* toilet add-ons available online (there are a few on Amazon.com). These can be slipped onto your toilet seat with ease. *If you make one change to Frenchify your bathroom, it should be the addition of a bidet.* It will change your life for the better.

The other element of a French bathroom that I miss in my American bathroom is the electric towel warmer. This is a modern device, one I've found in bathrooms all over Europe, so I can't claim that it is an exclusively French bathroom accessory. Still, almost every bathroom in France has one of these magic ladders, and I've never really understood why other parts of the world have not followed suit. Essentially, it is a simple metal rack mounted on the wall and plugged into an energy source. Before you take a shower, slip your towel onto one of the rungs. When you step out, your towel will be toasty warm. After you've dried off, slip your towel back

onto a rung and the warm rack will dry it quickly. It's a small luxury, one that we can surely survive without, but isn't taking pleasure in small, simple luxuries what living well in our homes is all about?

Another small, inexpensive luxury—this time for the *toilette*—is perfume. The Postel-Vinays' Parisian *toilette* is a very simple space, with white porcelain tiles on the walls and floor, a bird bath of a sink, a cake of white soap, a discreet toilet brush, and a single silver ring holding a pale hand towel. There is nothing else in the room—no reading material, no extra rolls of toilet paper, no amusing pictures on the wall—nothing else but a single bottle of perfume. Perched on a shelf, alone in all that white space, the glass bottle seems like a beacon of sensuality. One can't help but pick it up, aim it high into the air, and spray.

Although I have seen natural air fresheners and fragrances in many other bathrooms in France, no one does it quite like Madame Postel-Vinay. There is always a unique—never cloying or heavy—fragrance in her *toi-*

lette. She chooses fresh, inexpensive *eau de toilette*, or natural fragrances. The last time I visited, it was a bottle of lavender fragrance. She would never put out a bottle of Chanel No. 5; that would be silly and wasteful. Her choices are inspired by the raw scents of the south of France—lavender, jasmine, honeysuckle. Fresh, natural fragrances meant to counteract the natural odors of the room.

As with the *entrée*, the use of fragrance communicates your personal taste, but unlike the *entrée*—which is a public space, shared by many people at once—putting fragrance in the *toilette* is an extremely private gesture, appreciated by a guest in a most personal moment. One sprays the scent once, twice into the air, and the texture of the experience of using the *toilette* changes. One smells violets or rosemary. One leaves the room knowing whoever arrives on the scene next will smell flowers.

In the *entrée*, there are a number of ways to deliver scent—the vaporizer or fragrance sticks—but I have never found these devices in the French *toilette*. Likewise, I have never found those big aerosol bottles of "air freshener" like American-style Glade or Lysol that make you

want to gag, not only from the highly manufactured chemical scent they spew, but also from the toxic delivery system. These bombs of sickening scents should be avoided in your bathroom. It may cost a little more to have a bottle of natural home fragrance—especially if you choose to buy an authentic French one—but this is one area where you may want to splurge. If that isn't an option, you can make your own by mixing an essential oil like sweet orange or lemon verbena in a little water. Any kind of unusual and pretty glass bottle will work for this concoction, but a vintage glass perfume atomizer (authentic or reproduction) would make your bathroom both look and smell French.

I prefer to hold on to the idea of the French bathroom as that space from the nineteenth century, one with paintings and carpets and people hanging about as you wash. Recently, I've created this atmosphere in our home in the Hudson River Valley. The bathroom and *toilette* are separate. The *toilette* is tiny, like the French equivalent, and the *salle de bain* is dominated by a nineteenth-century porcelain claw-foot tub. I hung a large nineteenth-century mirror I bought in France in

the room, and added a restored antique cabinet for towels and shampoo and soap. It isn't enormous, so there's no room for more than this, but it feels hedonistic, less like a clinic than a sanctuary of repose and relaxation. The pre-twentieth-century French bathroom celebrates a certain kind of Gallic culture, one that valued pleasure and sensuality over efficiency and hygienic rigor.

Why not bring it back? Let's dismantle the staid havens of sanitation, those "factories of washing" that one finds today, and bring sensuality to the ritual of bathing. Let's add some color, some inefficiency, some luxury, and some decadence to the bathroom. It would spice things up—which is advice the French almost *never* need.

Salle de Bain

1. The *bidet.* If you change one thing in your
 bathroom, this is it. My recommendation is a
 Japanese toilet/*bidet* combination, but a separate
 bidet next to the toilet works just as well.

2. Install an electric towel warmer by the shower for
 the quick drying and warming of towels.

3. Use a perfume or a natural scent in your
 bathroom. My favorite is an antique perfume
 atomizer (or a reproduction) with an essential oil
 inside.

4. Find inspiration in pre-twentieth-century French
 bathrooms. With a large tub, lounging chairs or a

divan, pictures on the walls, large gilded mirrors, even a chandelier in your bathroom, you will find that soaking in your tub is more than just a functional endeavor. It is a moment of rejuvenation and pleasure.

7

Le Bureau,
La Bibliothèque,
and *Les Archives*

U nlike most other spaces in the French *maison*, the *bureau*—an office or a den—is not found in every home. One obvious reason for this is space: if your home isn't palatial, an office becomes impractical. Even if you have extra space, you might choose a guest bedroom over an office, especially if you don't actually need a home office. In Paris, where apartments can be the size of a

closet, there often isn't a choice: the *bureau* is integrated into other rooms. Desks, bookshelves, family papers, and such are set up in a hallway, living room, or bedroom. The *bureau* should be located wherever feels and looks natural—except, of course, in the kitchen or bathroom. *The importance of the bureau is not where it is, but what it does.* A desk in the hallway, an *escritoire* in a nook in the dining room, a *bibliothèque* in the bedroom: the placement of your office doesn't matter, so long as it adapts to you, your needs, and your goals.

Jacqueline Manon, for example, put an *escritoire* in a corner of her dining room. This small, wooden desk could be unfolded when she needed to write a letter or pay her bills, and closed just as easily when guests came for dinner. There was a lot packed into this little desk— stacks of bills, a jar filled with fountain pens, glass paperweights (she loved the hand-blown art glass variety, which I collect as well), and a silver letter opener— but it was easily tucked away the moment she didn't need it. Its position reflected its value in her life. She wasn't about to waste an entire room for a place to pay the bills. The extra room upstairs? She converted it into a large

closet, or *dressing* as the French would call it. Her clothes came first; paying the bills came second. And Jacqueline always looked great.

My mother-in-law works from home, and thus a *bureau* is a priority for the Postel-Vinays. Instead of sacrificing one of their three bedrooms, they put their home office in a corner of the *salon*, a very large room that could accommodate the intrusion. The desk is positioned next to a window overlooking the Eiffel Tower—this is where my mother-in-law edits her medical journal—and a second desk is placed against the wall, where my father-in-law works on the medical app he is developing when he isn't at the hospital. A bookshelf of reference books and meticulously organized *archives*, or family papers, fill one wall. It is strangely unobtrusive, maybe because the office furniture is so similar to that of the *salon*—understated, elegant, and in neutral colors. Thus, the room can function on two tracks: Madame Postel-Vinay can have meetings in the office that move over into the *salon*. The *bureau* is so discreetly integrated into the space that, if you didn't know to look, you might not even notice it was there at all.

An important consideration when creating your *bureau* is not only where it will be located, but also how to organize and store all of the stuff that lives in your office. Books, for me, have always been a source of consternation: Where on earth should I put them all? It used to be that I thought this a minor question. After meeting my French husband, I knew this was not the case. In the beginning of our relationship, he would invite me to his apartment in the 2nd *arrondissement* of Paris, and I would always end up in front of his bookshelves. Honestly there wasn't much else to look at. His was a small, mansard-roofed apartment with a galley kitchen that gave onto a living room/dining room with a compact bedroom on a half floor tucked up a flight of stairs. Space was tight, and his furniture minimal. Large and luxurious, however, was his collection of books.

There was an entire wall filled with them: art books and translations of Japanese novels and leather-bound Proust and books about cinema. I could get lost just looking at them all, they were so distinctly arranged, each subject standing together, as if expressing a philosophical camaraderie. His bookshelf wasn't a dumping ground for

the books he'd read; it was a highly curated gallery that expressed his taste, his education, and his passions. This, he informed me, was his library (*bibliothèque*).

For many years, I thought he was making a mistake in English usage, using the word *library* to mean "bookshelf." When he said we needed to make a *library* in our apartment in New York City, I pointed to the shelves filled with our books. He would glance over my mixture of paperback novels, dictionaries, museum catalogs, and shake his head: *That was not a bibliothèque. I was confused. The library is the building that houses books,* I told him. *Not something in an apartment.* I came to realize that he wasn't misusing the word *library* at all. For him, a library certainly does exist in an apartment. In fact, the *bibliothèque* is one of the most perfect expressions of identity in a French home.

Let us endeavor to understand the difference between the *étagères à livres* (bookshelves) and the *bibliothèque* (library) in a French home. As someone who collects books and has always had an enormous number of them piled on bookshelves, radiators, windowsills, and the floor of my home, I assumed that every book-

shelf functioned in the same fashion: as a receptacle for the books I had read. But the bookshelf and the *bibliothèque* are very different animals in a French home. *The bookshelf is a device for storage; the bibliothèque is an expression of a home's culture.*

Perhaps this is because in France, you are what you read. Or, at least, you are what you include in your *bibliothèque*.

For the French, what you read is more important than the clothes you wear, the car you drive, the rings on your fingers, or the watch on your wrist. Books are more important than the job you perform, or how much you earn per year. Money doesn't buy you respect in France, but a love of culture (and especially books) does. In a society obsessed by education, intelligence, and taste, books are also an important link between who you are and what you tell the world. The books speak for you. The books you read matter. The books you display in your home matter even more. The absence of books in your life signals a deep and inexplicable void.

Good taste is something learned through experience, through family, through culture. In other words,

there are no shortcuts to *le bon goût*. And while it may seem strange that the French—who are one of the top producers of luxury goods in the world—dislike brazen displays of wealth, it's true: they branded Nicolas Sarkozy the *bling bling* president because of his penchant for flashy watches and yachts. Such flamboyance is the essence of bad taste. In Paris, it's better to talk about the book you read last weekend than to show off your Rolex.

It seems very far away from my American world, this idea that culture matters more than money. Yet, even in commerce-obsessed transactional societies like ours, there still exists the aspiration to transcend materialism and find meaning in ideas. We Americans may appear to be less invested in culture as a status symbol, but we size each other up all the same. My first instinct, upon seeing a collection of books, is to make a correlation between book and collector. You must assume that every person coming into your home will see the *bibliothèque* and will form an opinion of you *based on these books*.

After initiation into the secret of the *bibliothèque*, my encounters with French bookshelves made more sense. I remembered the bookshelves I'd found in the home of a

friend living in Paris, an American writer married to his French book publicist. The shelves holding the American writer's books were chaotic—English language literary fiction of every stripe mixed with prepublication galleys and various tomes of nonfiction. It looked like books were deposited on the shelves willy-nilly, without system. But, in the midst of this clearance house of printed matter, there was one bookshelf that stood in contrast. Even if the books on this shelf weren't written in French, the method of organization, the arrangement of the spines by size and color, and the nature of the books would have made it clear that my friend's wife had claimed this bookshelf as her own. This was the French *bibliothèque*. What defines such a creature? If you were to ask the Frenchwoman who created it, she would most likely give a nonchalant Gallic shrug and say she has no idea. But I contend that *the bibliothèque is a highly constructed object, one meant to convey complex aspects of the personality. Much like the entrée, the bibliothèque sings your praises so that you can remain silent.*

The top few shelves of this woman's bookcase were filled with elegantly bound *Pléiade* books, which are a sta-

ple of the French book lover's library. Composed of eight hundred volumes, *La Bibliothèque de la Pléiade* collection is a leather-bound series of classic and contemporary authors. Like Everyman's Library, Modern Library, or Library of America (which was directly inspired by *Pléiade* editions), these books are often collected and displayed in the French home, and there can be a lot of passion (and cash) spent in the pursuit of a sizable library of *Pléiade* books. Some collectors become obsessed with having a complete set; others want rare and limited-edition items. For example, every year the publisher issues a *Pléiade* yearly planner, a small and elegant calendar bound with the same infamous leather as the series. Because this planner is given as a free gift with the purchase of three *Pléiade* editions around Christmastime, there is an extremely narrow window in which one can acquire the next year's planner. Having one is the ultimate sign that you are a sophisticate.

While non-French speakers have no reason to collect the *Pléiade* series, they do have a reason to create a *bibliothèque* in their home. No *maison* is complete without one. *Like the objects in your entrée, you must choose*

the books that represent your taste, view of the world, and passions. Make it personal. Making a shelf or two for the classics you've read and enjoyed—or that you hope to read one day in the future—is a way to show that you are alive, awake to culture, and engaged with the world of letters and ideas.

Build your library slowly, adding books year by year. Begin your *bibliothèque* with hardcover classics, those you've read and those you hope to read someday. I collect the Everyman's Library and the Modern Library editions and have, over the years, accumulated close to one hundred volumes. I haven't read them all yet, and so these books have become an aspiration: they give me something to look forward to every time I see them.

These books are beautiful objects, weighty, the promise of pleasure in their thick paper and elegant typeface. I love my books as *physical objects.* Of course, you can always read Flannery O'Connor's work as an e-book, download it onto a tablet, and never feel its weight or touch its pages. But the physicality of books—the way they inhabit space and remind one of their enduring relevance—is essential. It is much more pleasurable

to hold the Library of America edition of Flannery O'Connor's collected works, to look at her photo on the cover, and read biographical details on the jacket, to run your finger over the paper.

Most important of all: love your *bibliothèque*. Add books to it regularly. Share them with the people in your life. Allow your home library to be a place for the exchange of ideas that lead to genuine discussion. As the digital world continues to encroach upon our privacy, these exchanges may become more and more rare, and we must continue to actively cultivate them. Your books are a way to exchange your ideas with those you love, and those you deem close enough to enter your home.

If the *bibliothèque* is the moral and philosophical center of your *bureau*, the most practical element is *les archives*, or home archive.

I first noticed a home archive when I lived in the south of France. I was invited to a friend's for dinner, and after entering the living room, I saw a large wooden cabinet filled with thick, colorful files. They were neatly

arranged, like something you would find in the archives of a museum. Upon closer inspection, I saw the contents of each file had been labeled on the spine: ELECTRICITY, HEATING, SCHOOL, TAXES 2010, TAXES 2011, HEALTH INSURANCE, HOME INSURANCE, etc. When I asked my friend about this, she said, *It's our archives,* as if it were the most obvious thing in the world. When I told her that we didn't have such a thing in American homes, she was even more confused. "Then how do you keep all your papers straight?"

It was a good question. If we could have stepped into my home office at that moment, my friend would have seen the physical evidence of my confusion. I was in desperate need of an organizational system like her *archives.* My papers were a mess. I worked from home in my private home office, and all my personal and work-related papers had amassed in one room. For the longest time, I had no system at all: I had stacked papers on my desk, then on a bookshelf, then on the floor. My tax returns, medical bills, insurance policies, and family documents—birth certificates, passports, immunization records, etc.—were all mixed together in a jumble. Pages

were dog-eared, ripped, and bent in half. When I needed an important document, it could take an hour for me to sort through these messy stacks. Organizing these papers was so daunting a task that I simply ignored it.

Until the day came when I could ignore it no longer. I needed to find my daughter's immunization records and spent an entire Saturday afternoon buried in papers. Knowing I needed to get organized, I bought a small metal filing cabinet. It looked sleek and efficient in a corner of my office, but I found it to be a deeply unsatisfying piece of equipment. I had thought it would be a pleasure organizing my filing cabinet, to create labels on the thin hanging folders, and to slide my paperwork inside. But I found that I hated the whole thing—the sliding drawers on their metal runners, the flimsy folders, and rummaging through the compressed folders jammed with masses of papers. It also became a mess, nearly as untenable as my *no system* system. And so I took to opening the drawers of my filing cabinet and throwing my papers inside without filing them at all.

After seeing my friend's *archives,* I decided to try to create my own *archives.* I bought ten oversize bind-

ers, a few boxes of clear plastic sleeves (with the edges three-hole punched), and a Sharpie. I labeled the spines of binders with all the categories I needed. I then went through *all* my papers. Each important document was slipped into its own clear sleeve and then into the correct binder. I bought colored dividers to slip between sections. The TAXES, for example, housed all of my tax returns where colored dividers separated the years. The HEALTH binder held all immunization records, health insurance claims, and such. When I finished, I put the binders together on a shelf, where they were easily accessible.

It took time to create this system, but I've saved countless hours and much frustration now that I have it. The biggest benefit is how exceptionally easy it is to find documents when you need them. It could be because of meticulous labeling, but for me, this system works because everything is visible and easily accessible. There is no sorting through masses of files and papers.

Another benefit to *les archives* is that all of your important papers—birth certificates and marriage certificates and passports—are protected by clear plastic

sleeves. In France, keeping these documents in good order is essential, as one cannot order a replacement birth certificate. If you lose it, it is gone forever. And while it isn't this difficult to replace lost or damaged documents in other countries, in France it is just not possible. Hence, the care given to keeping track of them.

I should mention here that while other countries have significant amounts of papers to organize, the French win the gold medal for bureaucracy and paperwork. When I was living in France, I was told to never throw anything away, as I would need it down the line (for tax purposes, proof of payment, proof of identity, etc.). Almost everyone who has lived in France has a story to tell about being sent from office to office, being given different papers at each one, and being asked to keep all of them. When I've asked why this is the case, I've been told that Napoleon and his centralization of government is to blame, but I can say that private companies in France are just as bad. Try getting a cell phone or opening a bank account. It can be treacherous. Which is why French people, in a brilliant protective measure, created a system for combating bureaucracy: *les archives*.

After I made my *archives*, I wondered why I hadn't thought to do this before. It isn't an original system, by any means. There are many home offices all over the world filled with binders and folders. Thinking back, I recall the folders and binders I used in middle school were similar. I distinctly remember a Mickey Mouse binder I had in fourth grade, all its subject folders tucked inside. And museums and libraries have been storing documents with archival methods for hundreds of years. They are in use everywhere, not only in France.

But in France, you will find this clear, logical, and simple method of organizing and storing documents in every home. *Les archives* are a fixture of the French *maison*, as universal as *le salon, la cuisine,* or *le boudoir.* Everyone in the family knows how to use this system, and everyone is encouraged to file their papers correctly. Now, whenever I enter a French home, I glance around, looking for the *archives.* Sometimes they're easy to spot—the binders and archival boxes are out in the open—and sometimes they are hidden away in a cupboard, but you know that every French family has one somewhere, a time capsule of their lives.

*L*e bureau, la bibliothèque, and *les archives* are the organizational motor of your home. Their basic function is to systematize and classify. The *bureau* keeps your work in one place, the *bibliothèque* systematizes your intellectual preferences, and the *archives* keep your bills and family records in order. The French are a systematic bunch, and their Cartesian minds love a good method of classification, but your home office, library, and archives need not be bland, OCD, or lifeless. Using the concepts the French have developed, you can improvise, creating these essential systems to match your own style. Be creative and have fun.

CREATING YOUR FRENCH

Bureau, Bibliothèque, and *Archives*

* When designing your home office, remember that
 it isn't important where you put it, only that it
 functions for you and you alone.

* To make your *bureau* an integral part of your
 space—especially if it shares a room or is in the
 hallway—use the same style of furniture, same
 colors, maybe even the same kind of artwork as
 other parts of your home. Madame Postel-Vinay's
 office is well integrated into her *salon* because she
 chose similar furniture and colors.

* Make a *bibliothèque* or home library in your home.
 Make it public, so that guests can see and discuss
 your books with you.

* Choose books that represent your taste and interests. If you hate classics, it is better to fill the shelf with contemporary writers, for example. If you don't read much, make it a habit to buy books you aspire to read in the future. Buy Everyman's Library or Modern Library books to create a program of reading and slowly build your library.

* Organize all of your papers, medical records, and family documents (birth certificates, passports, immunization records, etc.) into an archived system of folders.

* Classify for ease. Buy large binders and clear plastic sleeves. Mark each binder with a subject and put your papers into the sleeves.

* Follow Jacqueline Manon's advice about following the rules and then having fun. These systems are only in place for you and your life. Make them fit your needs.

8

Le Foyer
and *La Cave*

Some of the most deeply loved spaces in the French *maison* are not rooms at all but areas of the home that carry the heavy weight of family and tradition. The hearth (*foyer*) and the cellar (*cave*) are two such spaces. Metaphorically speaking, the hearth is the heart of the home and the *cave* is the guts. Together, they bring blood and courage to the inhabitants.

The first time I heard the word *foyer* in French was during my wedding ceremony. We were in Port-Blanc, a rocky town in the Côtes d'Armor of Brittany, where the Postel-Vinays have a summer house. Port-Blanc is known for its fickle weather, a harbor packed with sailboats, and fat, briny, Atlantic oysters. My husband was baptized in this town and spent all his summers there as a child. Many of the Postel-Vinay family's happiest moments occurred in Port-Blanc, and so Hadrien and I decided to get married in the rustic, ancient chapel there.

On the day of the ceremony, we stood side by side before the priest, family, and friends filling the chapel. As the *abbé* gave the benediction, he reminded the congregation that one of the four pillars of a marriage in the Catholic faith is the creation of a *foyer*. I didn't understand the word in that context in the moment, but when I looked it up later, I found that the *foyer* is the hearth, the place where one builds a fire, the symbolic center of the home and family life.

In English, a foyer is an entrance, hallway, or reception area and has nothing at all to do with the French word I heard at my wedding. I've found that French

words and concepts often transform completely once they arrive on American soil. Take the term entrée, the plate of food you order in a restaurant. In France, an entrée is an appetizer. In America, it's the main dish. Same word, exactly the opposite meaning.

The word *foyer* is a *faux ami*, a false friend, a word that tricks us into believing the French *foyer* and American foyer are the same thing when there is no correspondence between the two. What we can say for certain is that the *foyer* and, by extension, the fireplace has an elevated, an almost religious, position in the French home. It is the bedrock of their living space. It is the symbolic source of heat and light.

The French are not alone in their reverence of the fireplace. Before central heating, the fire was needed for survival in most northern countries. As a result, we associate the fireplace with comfort, coziness, warmth, and family. Traditional Japanese homes and inns have a fire pit at the center of the main room, where an iron pot can be hung to cook stew or *nabe*. The Danish practice of *hygge*, or coziness, relies on candles and fireplaces to create a cozy ambiance. In the long, freezing winters of

my midwestern American childhood, we often burned logs in our large, stone fireplace. When there was a fire, everyone joined together with no purpose other than to be *en famille*. We rarely had the TV on when the fire was burning. We were drawn to the hearth, and its warmth brought us all closer.

But the French reverence for the fireplace goes deep into the ideology of the idealized French family, the hearth and home. The first time I was invited to my husband's summer house in Brittany, it was a rainy and wet spring weekend. We spent nights by the fire, eating and drinking wine and talking until late. We went to bed with the cinders glowing, and in the morning, the remnants of the logs lay scattered below the trivet. The process of creating fire, watching it blaze, and witnessing its slow sputtering demise plays out our human trajectory—we burn bright, find others with whom to share warmth, and fade. This intimate experience, unspoken and utterly primal, reminds us what is important in life: family, friends, and the experience of time as it recedes. It wasn't by chance that Jacqueline set the table in front of the fireplace the first time she had me in her

home. The fireplace was the very center of her emotional life, the place she chose to bring me into her life more fully. It was my initiation into her family.

Obsession with the fireplace is still paramount in France. Recently, in an effort to reduce pollution, a ban on burning wood was proposed in Paris. It was overturned just a few days before it was to take effect due to widespread protest. Ségolène Royal, the environmental minister, called the ban "ridiculous" and reversed it. Meanwhile, a 2014 law banned fireplaces in all new constructions in New York City. There was no public outcry at losing this traditional part of the home. On this side of the Atlantic, no one seemed to mind much.

A few months ago, I was paging through the December issues of French home design magazines. These were Christmas issues, and so the messages conveyed in many of the articles had to do with family and staying warm, friends sitting around a hearth drinking wine, and cozy rooms with snow piling up outside the window. There were candles on the mantels and soft lighting in these images, emphasizing the importance of fire in the dark month of December. Many of the advertisements lay-

ered through the magazine were for stoves called *poêles*, which appear to be replacing old-fashioned fireplaces in French homes. These stoves can be easily installed, and some models don't require a chimney. Often freestanding, they burn wood pellets or run on electricity or gas, and they create a magnetic center for the *salon* even if your home doesn't have a fireplace. The French love the idea of the fireplace, even if their space doesn't allow for the physical manifestation of one.

Though using a fireplace as the primary source of heat in a Parisian apartment has been outlawed since 2007, fireplaces are still in wide use. Even when the chimneys are stopped up with brick, they still serve as a decorative and symbolic element in the home, and while no one sits around a barren fireplace, they still bring the feeling of warmth into a room. The Postel-Vinay apartment has five fireplaces, one in the dining room, one in the living room, and one in each bedroom. All of these marble mantels and sculpted frames are now merely decorative, but they would never dream of removing them and putting something more practical—a bookshelf or couch—in their place. Over time, many older apartment

buildings have stopped using their fireplaces—but the French never cover them. The fireplace is no longer used for heating the home, but it is valued for its ability to create a sense of connection and warmth. For the Postel-Vinay family in Brittany, this connection is physical—we sit around the fire, talking and enjoying the warmth. We bring in logs and sweep up ash. In Paris, the fireplace becomes a symbolic stand-in of this connection. It reminds one that the hearth is the symbolic basis of the family, even when there's no actual fire.

A symbolic *foyer* doesn't have to involve heat at all. You can create the illusion of fire with the same effect. When Hadrien and I lived in our modern New York apartment, we had nothing resembling a wood-burning fireplace. My solution was to play a Netflix video called *A Fireplace for Your Home* on our wide-screen television. The video is nothing more than a close-up of a fireplace filled with burning logs, and for one hour, one sees these logs smolder down. I would turn the volume up, so the sound of a crackling fire would fill the apartment. There are a few variations on the video—one with music, one with birch logs—but I prefer the clas-

sic one. Whenever I turned it on, I felt the same sense of warmth, safety, and homeyness that I did in Brittany.

Whereas the fireplace is the metaphorical heart of the French home and is usually the centerpiece of the *salon*, the *cave*, or cellar, is hidden away in the dark regions below. The word *cave* is close in meaning to our English word cave: a dark, cool, and hidden place that shelters precious substances from invasion. Typically, the cellar is a small, windowless room below the house, usually in a basement. Once upon a time, it was a cool place for root vegetables, cheese, and aging meat, as well as wine. In Paris, there is a substratum below each building filled with *les caves*.

In ideal conditions, a cellar remains at thirteen degrees Centigrade, or fifty-five degrees Fahrenheit, the natural temperature of soil below the surface of the earth. The cellar insulates wine from cooking or freezing, but it also protected treasures from thieves. Every so often, you will read stories in French newspapers of homeowners digging up gold coins, silver, and other valuables in their

cellars. Before banks, safety-deposit boxes, or iron safes, the cellar acted as the strongbox for a family's wealth. It was the place of buried treasures.

Even now, in modern French homes, the cellar carries the import of protecting the past and fortifying it for the future. The cellar is about preservation against erosion. It is about holding on to the past and delivering it unscathed to the future. In this regard, the cellar is a feature of the French idea of family: what once was shall be again—we must simply keep it from harm.

Wine ages slowly and requires time to reach perfection. It glories in it. When you keep wine, you are, in some senses, holding on to time. The year I married, I bought a few bottles of Champagne, wrapped them in paper, and put them in my cellar, thinking that it would be romantic to drink them after ten years of marriage, twenty, even thirty. In order to guard these bottles from the fluctuations of temperature, which would erode the taste and cause the wine to go bad, I put them in the back of the cellar and let them age.

The French have an emotional connection with their cellars. The *cave* is not just another kind of cold storage

unit. It is a time capsule, a protective shield for the beautiful things we wish to keep from erosion. It is a way of stopping time, or at least slowing it down, so that we can exist with the illusion that what we love will not simply dissipate. Champagne can live on for many generations in the cellar.

The idea of hidden treasure and buried secrets is wrapped into the very origin and function of a cellar. Over the years, I've learned that the French are very secretive about what they have—no French person will tell you how much something costs or how much he or she earns; it is considered rude to ask or to offer details about your personal wealth; and no one brags to friends about bonuses or their income. Americans expect such disclosures and rely on them to subtly gauge social status and hierarchy. French people, on the other hand, do not use wealth as a distinction, and do not reveal their fortune (or misfortune) easily. They aren't trying to be sneaky or condescending. The French have other ways of revealing themselves—where they went to school, their profession, a family name, and so on. They *want* to believe that everyone is equal, no matter what his or her

financial situation may be. Of course, this is all an illusion, as the French care as much about money as anyone. Only in France, wealth does not translate into status and power the way it does in America. In France, culture and taste—what you're *thinking* and what you're *doing* and what you're *reading*—are more interesting, more alluring and seductive, and therefore more powerful than your bank balance. It is considered very bad taste to talk about money—and you should keep your precious possessions hidden away.

In the older buildings in Paris, a cellar was customary, with each apartment allotted its own underground dungeon. In the last hundred years, larger apartment buildings were divided, and the tiny top floors turned into studios, leaving fewer cellars than residents. Newer buildings do not always have these spaces, and cellars have become rare and coveted, prone to incite primal feelings of envy among neighbors. Parisians who were not lucky enough to secure a space below their apartment building create a cellar upstairs, in their apartments. They put a wine refrigerator, small or large, in the *cuisine* or a closet. And while this certainly keeps their

wine cool, I wonder if it quells the emotional yearning for a dark, safe place for their treasures?

The majority of the cellars I've visited in France have been in old houses and tended to be everything one imagines a cellar to be: damp, dark, dusty, and poorly lit, with cramped rows of racks, as gothic as the cellar in Edgar Allan Poe's "The Cask of Amontillado." A cellar in California can look like a BMW showroom, all sparkling with chrome and glass. I've read articles in wine magazines featuring collectors in Napa or Sonoma who have cellars that are clean, well lit. These are highly showy spaces with expensive bottles on display, a tasting bar where friends can drink wine together and where even weddings can take place. These cellars, like my childhood living room, multitask to the point of blandness.

When I lived in the south of France, my cellar was in a closet under the stairs, a space that wedged into the limestone of the village. It was long and narrow, more like a tunnel than a room, and I hung a flashlight at the door to help me see through the thick, cobweb-laced darkness. If I packed the cellar carefully, I could have stored several hundred bottles of wine down there, but I

never came close to filling it. In general, the wine I stored in my *cave* had emotional value. As with the bottles of Champagne I bought the year I was married, I purchased bottles of wine from the years my children were born. I found vintages that would age well, and I plan to present my children with these bottles when they are older—maybe when they graduate from college or get married—so that they can experience something that has been growing and changing over time, as they have.

Much of my wine was collected in a haphazard fashion. I liked to visit small vineyards and buy wine to remind me of the experience. The amount of wine I collected interested me less than the feeling of discovery I experienced as I opened the creaking door, cleared away the cobwebs, and peered into the dark mouth of the *cave*.

The cellars of newer homes can be quite different from the old ones. I've visited clean and well-lit cellars, with none of the granular, fungal air of a traditional *cave*. Indeed, I've stepped down into a modern cellar equipped with bright lights, air-conditioning, stainless-steel refrigerators, and a computerized catalog of the wines in storage. While these French cellars have the streamlined and

technological aspects of many French kitchens, where the idea of science and system reigns supreme, they have little to do with traditional French *caves*. It makes me wonder if such modern cellars, with their fancy gear and efficient system of classification, don't give a French *maison* a sense of negative space, an absence, a sad, lingering longing for shadows and secrets.

Now the French use banks and safes, like everyone else, to stash cash and valuables. They use temperature-controlled refrigerators for perishable food, and freezers to preserve meat. Modern wine storage is ruled by technology, and there are functional systems that can be installed anywhere in a home. There's no longer a need to keep wine hidden underground in a dusty dark space. And yet most of the French people I know still keep a cellar and wouldn't give it up for the sleekest wine fridge in the world. The *cave* has remained a part of the French home and remains deeply important to the French sense of cultural heritage. Despite modern technologies, Parisians will sometimes fight with neighbors over a tiny underground parcel of the basement. This is because the cellar, while offering the practical function of wine stor-

age, also offers an even more important function: *the cave is the root system of the home, a space that anchors the family into the loamy, nutrient-rich earth. The cellar keeps the French home grounded. It gives it depth*

Now, the French *cave* is used exclusively for wine storage, not for hoarding gold coins. They are simple, functional nooks with wood or metal racks where bottles of wine are placed in slots. Most of the wine lovers I know have a system for organizing their wine, usually by region, then date, with bottles meant to age stored toward the back, making it easy to remove the bottles meant to be drunk sooner.

The wine you store in your *cave* should not be the wine you plan to drink now or even in the next few months. These bottles can be kept in your pantry upstairs, or in a small wine fridge, if you have one. Wine to be cellared is for the future, and you should plan to drink it later in your life, sometimes many years later. Some wine is never drunk at all but passed down to the next generation as an inheritance. I've sometimes thought that the French feel about their cellars the way Americans feel about life insurance. A disaster is un-

likely, but if it happens, there is protection for those left behind. Of course, life insurance doesn't erase the pain of a family tragedy, and neither does a fully intact cellar full of vintage Bordeaux. But the impulse for having this repository is emotionally similar: should disaster strike, we want to know that we have left something behind.

The *foyer* and the *cave* are two spaces in a French home that have a deep emotional and psychological resonance. Taking these emotional elements into consideration is an important part of not only creating your space but also deciding *who you are as a home dweller.* Creating a *foyer* and a *cave* will require extra thought and soul searching. Who do you want to enter your home? What treasures do you keep locked away? Not everyone has a fireplace, but everyone has a sense of who belongs in their home and who should (or should not) have a place there. Not everyone has a basement *cave,* but we all have a sense that there are things worth saving, objects we hope to preserve for the future. These are the ideas to keep in mind as you consider creating your own *foyer* and *cave.*

It took Jacqueline a long time to invite me to her

house for our asparagus lunch, and even then, she did so with caution, showing me first only the *entrée* and the *salon*. Many more months passed before I was invited upstairs, to the secret regions of her home such as the *boudoir,* or into the basement, where she stored wine, as well as canned fruit and vegetables. I had to earn her trust. She was testing me to see if I fit the spirit of her space. I always had the sense that Jacqueline believed her home had a power of discernment, that it chose those who entered, and that her home was a sturdy and unmovable guardian.

Cave and Foyer

* If you have a fireplace in your home, make it a focal point of the room. Use it regularly and invite family and friends to sit near it to talk whenever possible. If you don't have a fireplace, consider getting the efficient *poêle*, a gas-burning fireplace, or a wood-burning stove.

* Use your television as a symbolic *foyer* by playing fireplace videos such as Netflix's *A Fireplace for Your Home*. This is by far the quickest and easiest way to bring the coziness of a fire into your living space.

* If you are a wine drinker, create a *cave* to store your wine. The best spot is in the basement

or cellar, in a dry cool spot that has no direct sunlight. If you don't have a basement, a dark closet will do. Get a wine refrigerator to keep the temperature at around 55 degrees Fahrenheit.

9

La Chambre

My father was born in 1944 in a small stone farmhouse in the rural Midwest. He was the son of farmers, devout Catholics who raised twelve children in a home with only three bedrooms and one bathroom. The children shared bedrooms and sometimes slept as many as five or six kids to a bed. There were more boys than girls in the family—eight boys and four girls—so my father's sleeping arrangement was significantly more crowded than that of his sisters. I once asked my dad

how he'd managed such crowded quarters. Try as I might, it was always hard for me to imagine living that way. He told me that it was never a problem for him. In the harsh midwestern winters of his boyhood, his bed was always warm.

While my father was born only seventy-five years ago, his childhood home seems like ancient history to those of us who live in modern homes. Today, even the most modest dwellings generally afford us a mattress of our own. When space is tight, we opt for bunk beds, trundle beds, Murphy beds, or even air mattresses rather than piling five or six people into one large bed. The lack of space, the forced intimacy, the absence of privacy— such conditions are far outside what is considered the norm in modern life.

But after spending time in France and speaking with some older Parisians about their childhoods, I learned that French life in the early twentieth century was not so different from my father's in his farmhouse. Danny of the perfect silverware drawer grew up in a small apartment in the 7th *arrondissement* in Paris. His father was the building caretaker or concierge, and their ground-floor

apartment was far from spacious. He and his brother slept together on a narrow bed in a closet-size room. He didn't see this as a sign of poverty or deprivation. It's just the way it was back then. Almost everyone shared a bedroom. Space was a luxury very few were afforded.

As discussed in the chapter on the *foyer* (see chapter 8), the middle and lower classes in France traditionally lived in small, crowded spaces where the hearth was the centerpiece of family life, making it customary for people to cook, eat, sleep, and even bathe in one space. They also slept *en masse*, much like my father did with his brothers, but their bedding was vastly different: instead of the mattress as we know it, people slept on pallets of woven straw or hay. This, as you might imagine, exposed one to all the little creatures that reside in hay: lice, mites, fleas, insects, and even mice. Heavy covers called ticking helped prevent insect infestation, as did storing the pallets and blankets in large cedar chests, or *coffres*. These chests were also used for clothes storage and were often elaborately carved. Eventually *coffres* would be replaced by the traditional staple of French bedroom storage: the wardrobe (see below).

In large medieval dwellings in Europe, the wealthy slept on beds that were like miniature rooms—large four-poster wooden structures with curtains or wooden doors on every side, to keep away drafts and the curiosity of peeping servants. English author Thomas Trollope, on a visit to Brittany in the nineteenth century, described a traditional wooden box bed or *lit clos* as "a huge dark oaken piece of furniture" that had the appearance of a "cloth-press." These wooden structures were often the most expensive pieces of furniture in the home and were passed down through generations. In seventeenth-century England, William Shakespeare left his wife his "second best bed" in his last will and testament. Clearly, he was making a point about his relationship with his wife. That said, the second-best bed of a household was still a significant asset.

In the past, sleeping wasn't considered the private and personal act it is today. I remember my fascination upon seeing the bedroom of Louis XIV in Versailles. Like all the rooms in the Sun King's private apartments, there was an elaborate etiquette regarding who

could enter or exit the bedroom. As there were no entirely "private rooms" in the palace—the rooms were strung out in a line, and one had to walk through each room to get to the next one—the very notion of a "private chamber" in Versailles was very different from ours. But the king's bedchamber was particularly public, as it was the site of the famous ritual of watching the king rise in the morning—the *grand levée*. In this highly formalized event, members of the court gathered to witness their ruler awake each morning, rendering his opulent bedroom more of a theater than anything we would consider a bedroom, a little like having a live webcam in the presidential master bedroom of the White House. The whole idea of such a public display around sleeping—now considered one of our most private and secluded activities—is hard to envision. But even more odd is the level of intimacy this ritual created between the king and his subjects. They knew their king without powder or clothes, without wigs or stacked heels. Imagine waking up with no time to put yourself together—to brush your hair or teeth, or to go to the bathroom—before being

thrust before an audience. The very thought of this takes the issue of bed head to another level.

The luxury of having privacy in the bedroom is a modern invention. In her study of French homes *Nos Maisons*, Beatrice Fontanel writes that in the Middle Ages, the bedroom was a much more public space, where many things occurred: working, dressing, sleeping, and bathing. In large households, there was always the danger that someone might make off with the valuables kept in the bedroom, which contained *les coffres* holding expensive clothing, jewelry, shoes, and other necessities. Fontanel notes that the mistress of the house often had a large number of keys on her belt. The only way to maintain security and privacy was to lock the door.

Now, of course, we expect privacy. Anyone who has been around a modern American teenager (or who has been one herself) knows that having a private bedroom is perceived as a requirement. When I was sixteen, I felt that I was entitled to this, that my "personal space" should be respected, and that I had a right to decorate my bedroom however I wanted. In France, teenagers

may not have quite so much freedom in bedroom décor, but their ideas of privacy are quite similar. There is a sense, in the modern French *chambre*, that the bedroom is one's refuge and island, the sanctuary where one can be free of the communal nature of family life.

Michelle Perrot, a French historian who specializes in women's history, and whose book *Histoire de Chambres* dissects the function of French sleeping quarters, has written of the bedroom as the most carnal of spaces, a place where the body spends half of its time, where dreams, desires, passions, losses, heartaches, and illness are experienced in a private space. But this privacy is a more or less modern invention, often attributed to foreign influence. The homes of the English aristocracy, in which interior hallways were created to lead one from room to room, produced private havens in which one might luxuriate in Perrot's private carnal space, and are sometimes blamed for planting the seed of individualism.

In my experience, *la chambre* is one of the most private rooms in the modern French home, one that (like

the *salle de bain*) you will most likely never see unless, of course, you are invited to spend the night as a guest. Even then, you are likely to see only the bedroom in which you will be sleeping. Before I met Hadrien, I had never actually seen a French person's bedroom. I had looked at photographs of designer bedrooms in magazines and had noted *la chambre* in French films, but my actual experience was minimal. I had lived in France for years and had been to a number of French homes, but I was never taken beyond the *salon* and the *salle à manger*. It is hard to get an invitation to dinner in France, let alone be allowed into the most private realm of the family. It seems the only way to get into a French person's bedroom is to sleep with one.

Indeed, after I fell in love with Hadrien, I saw quite a lot of his *chambre*. His apartment was, as I mentioned when describing his book collection, in the heart of Paris, and tiny by most standards. The bedroom was tucked up on a half floor with a mansard window overlooking a series of classic Parisian buildings. There was just enough room for a futon, a narrow closet, and a chair. When we went upstairs to bed, it felt like we were climbing into

a nest. And yet this aerie bedroom, however minuscule, met every standard of what I would define as the French *chambre*.

Namely, it was designed for the single purpose of going to bed. Whether that is to sleep, or to do other activities, is not the purview of this discussion, but I will say that from my experience the French use their bedrooms with a clear and definite objective in mind: to take off their clothes and get under the sheets.

Which are, for the most part, neutral in color, made of high-quality cotton, and without fancy patterns. Although French children's rooms often have the colorful IKEA sheets and furniture that have infected the world like a Swedish influenza,[*] most bedroom colors remain more or less subdued. The French prefer a pure, simple,

..

[*] The French are not immune to IKEA. In fact, they love IKEA as much as the rest of the world. When I lived in the south of France, I found that many of the antique stores were overflowing with beautiful old furniture. When I asked the owner of one store why it was that they were so well stocked, and the prices so reasonable, he told me that young French people don't want anything to do with antiques. They buy modern furniture from IKEA and throw out the furniture inherited from their grandparents.

elegant bedroom, without ornamentation. There is also a resistance to the matching décor so popular in America. I've never seen sets of matching curtains, shams, sheets, pillowcases, carpets, etc., in a French bedroom. There may be a color that ties the space together, but the effect is subtle and calming. Elegance always overrides thematic decoration.

In general, French bedding is not much different from our own, although I have had more than one French person arrive on American soil to find herself confused by the absence of the duvet cover. Although many Americans do cover their comforters with duvets—duvet covers are for sale pretty much everywhere—it is more common in the United States to have a blanket or comforter without a cover. One French friend who sublet a furnished apartment when she came to live in New York City was compelled to text me to ask how the bedding worked. She had found a fitted sheet, a flat sheet, and a blanket, but no duvet cover. In France, there is always a duvet cover over the blanket or comforter, and rarely (if ever) a flat sheet. When I told her that there likely wasn't a duvet cover, she wanted to know if she was supposed

to wash the *couette,* or comforter, every time she washed the sheets. The French see the duvet cover as a protective layer against stains, allowing one to remove and wash it weekly. The idea of washing the comforter itself every week was strange to her—and as we know not a common practice in America.

There are regional variations in bedding. For example, in the south of France, where the weather is generally mild, one finds traditional light quilted cotton blankets. My favorites are those made in the Provençal tradition of quilting, also known as *boutis,* in which a thin layer of cotton, silk, or wool batting is covered on both sides with thick cotton fabric, then quilted. My favorite *boutis* (Provençal meaning "stuffed") quilts are the floral-patterned ones, which are very popular in French country homes. I fell in love with *boutis* summer blankets one Sunday when I saw them by chance at a local market. I was walking with a basket full of vegetables when I spotted a stack of pale, floral-patterned quilts on a table. I went over, touched one, and discovered the softest, most comfortable blanket in existence. I ended up buying one for my parents and another few for friends, which I brought

back to the States as gifts. I can't imagine summer without a *boutis* quilt, and I recommend them for both their beauty and their comfort. Luckily, you don't need to go to France to find them. A recent search online showed many Provençal quilts available for sale, both authentic antiques and contemporary reproductions. When buying one for your bedroom, make sure that it is 100 percent cotton, including the stuffing.

In the French *chambre*, the bed is the centerpiece of the room, but it isn't the huge boxy wooden monster of the medieval era. Modern beds tend to be simple, without elaborate headboards or frames, while antique beds (which I personally love and owned in my home in the south) are more elaborate, with carved wood decoration. As this kind of old-fashioned furniture is not *à la mode* at the moment, I found my antique beds—three demi-corbeille tapestry beds in which the headboard was framed with carved wood and decorated with panels of patterned fabric—at the equivalent of a Salvation Army in Montpellier. (Jacqueline would have been proud.) Along with the Provençal *boutis* quilt, antique bed frames are my favorite French bedroom pieces. I particu-

larly like how they look in a modern home—the mixture of old and new gives a bedroom a unique texture. Reproductions of antique beds—everything from sleigh beds to four-poster beds to carved gothic beds—are available, as well as the rarer originals.

In keeping with the function of the *chambre* there is no watching of television, eating, wine drinking, or family time in the bedroom. Children usually have a table or desk in their rooms where they do homework, and of course, there are bookshelves for their books, and an *armoire* or wooden chest for toys, but not much else. I've never seen a television set in a French bedroom at all. The French read at night, rather than watch television, and there are always bedside tables with reading lamps on each side of the bed, often stacked high with all kinds of reading material.

The simplicity and minimal elegance of the *chambre* has much to do with having adequate and appropriate storage. The traditional furniture for clothes storage is the wardrobe, usually large wooden ones that have been passed down for generations. There was no possibility of getting one of those dinosaurs into Hadrien's tiny stu-

dio bedroom, and so he had a small custom-built closet, one just big enough to squeeze all his perfectly folded clothes. In the medieval era, the *garde-robe*, as the closet was called, formed an important part of a large home, and was a separate room connected to the master bedroom. Now, *le dressing*, or a walk-in closet/dressing room, is how the elite store their Hermès bags.

But no matter how you hang your clothes, the important thing to remember when creating your French bedroom is that it must be private, soothing, intimate, and comfortable. This is your more private space, the place where you spend a third of your life, where you dream and love and cry and recover from the abrasions of the world in private. Its primary function is to give you peace and pleasure.

CREATING YOUR

French *Chambre*

* Choose simple, soothing, minimalist colors for your bedroom, such as cream or gray. These should convey calm and comfort and encourage the main objective of the space: getting into bed.

* Televisions and excess furniture (couches, magazine racks, plant holders, etc.) should be removed from your bedroom to create a pure space.

* Use curtains or blinds to provide maximum privacy.

* Try using a duvet cover for your winter comforter, along with a fitted sheet (and no flat sheet). These and all bedding should be one color, without patterns. Don't worry about shams or frilly bed-ruffles. The simpler, the better.

* For warmer weather, hunt down a Provençal *boutis* quilt.

* Seek out an antique French bed frame, either an older piece of furniture or a beautiful reproduction.

* Remember, your bedroom is for bed, not for meals, family discussions, or work. Use the room for what it is intended, and it will bring you rest and joy.

10

Le Boudoir

After I left my hometown and went off to college, Jacqueline Manon and I stayed in close contact. On school breaks, I would return to visit her, spending long evenings solving Ravensburger jigsaw puzzles in her *salon* and talking. I had, over the years, learned more about her past and came to understand how the etchings in her *entrée* spoke of her own sufferings. I'd spent many more spring evenings eating the first asparagus of the season in her *salon*, our fingers full of butter and aioli,

and our feet warmed by the fire. And I'd passed count-less summer afternoons cooking in her well-equipped kitchen, the scent of herbs sweeping in from the garden. But of all the rooms in which I spent time with Jacque-line, my favorite was her *boudoir*.

It was a strange room, Jacqueline's *boudoir*, beautiful and full of antique furniture, but not stuffy or uncom-fortable. In fact, it was where you'd most want to spent time in Jacqueline's house, if she would let you. Most of the time, she would not. Jacqueline was very particular about whom she allowed into her *boudoir*. All of her trea-sures were kept there—the cases and caskets of jewelry she had collected over the years, and her most precious beaded dresses from the 1920s. Once, she pulled out a sheaf of love letters dated from the 1960s, showed me a few poetic lines from an old lover, then tucked them away again, as if hiding them from an intruder. She was afraid of theft, I'm sure, but more important was the fact that the *boudoir* was her most private space, the room where she spent time alone, or with only her closest friends. It was the room that held her personal secrets

and her worldly treasures. She didn't want to reveal either to just anyone.

Occupying the antechamber to her bedroom, the *boudoir* was a second-floor space with a long sweep of windows overlooking a park. What I remember most, aside from the feeling of protection I felt when I sat in the *boudoir*, was the sheer amount of reflection happening in the room: it was *full* of mirrors—a full-length mirror in a mahogany frame, a vanity table with a large round mirror, a gilded mirror hanging on the wall opposite the windows. Reflected from all angles were Jacqueline's possessions: dresses on hooks; antique jewelry in cases and trays; a rocking chair with an enormous silk shawl over the back; stacks of hardcover books; her diary, open to her last entry; a record player and a stack of records. All this was reflected back at me from wherever I sat.

It seemed to me that everything had depth and dimension in Jacqueline's *boudoir*. It was a well-tended and beloved chaos. When I arrived for a visit at Jacqueline's house, she would sometimes take my coat in the *entrée*

and say: "Let's have coffee in the *boudoir*." I had never before heard the word *boudoir* until Jacqueline said it. It sounded magical. Illicit. Sexual. French.

Boudoir derives from the French word *bouder*, to pout, and one can easily imagine how the room was used as a place of refuge, somewhere to go when the world was too cruel, a safe place to let one's guard down and do just that—pout. Traditionally, the *boudoir* was a female-only sitting room, a place where women spent time together. After dinner, men went to the *fumoir*, or smoking room, to smoke, drink, or play cards, and women went to the *boudoir*. The Marquis de Sade gave the *boudoir* a more scandalous spin when he wrote about his exploits, but the *boudoir*, in spirit, has nothing to do with seduction or racy sexual indiscretions. It is a place of repose, a sanctuary from the demands and judgments of the world. More intimate than a *salon*, and more public than a bedroom, the *boudoir* was a place where friends could drink, talk, get ready for an event, or just lounge.

Sometimes, on my visits to Jacqueline's home, I would walk up the stairs and find her stretched out on a couch in her *boudoir*, lost in thought, a book at her side

as she stared off into space. I had the feeling that she was totally free in her *boudoir*, able to let go of everything— even the dark memories of her childhood—and exist in another time and place.

For all intents and purposes, the *boudoir* is not a room but a fantasy, one that no longer exists. Jacqueline created this space, but in all the homes I've visited in France in the years since Jacqueline's death, I have never found even one with a *boudoir*. This space has disappeared in the French home. In the modern era, there's no protocol for men and women to separate during social events, and the *salon* and *salle à manger* are now the primary sites of gatherings. And yet, if you can, I urge you to create a *boudoir* in your home. The hours I spent in Jacqueline's *boudoir* were some of the most memorable moments of our friendship. It was here that she showed me her favorite box of rings, pictures of the vintage clothing store she opened in Berkeley, and the photos of her estranged son. These were some of the most private conversations we had, and I cannot imagine them happening elsewhere.

It may be out of fashion, but the concept hasn't disappeared entirely from the French home. There are still

small areas that women claim as their own. *Le dress-ing*, or dressing area, which I've found in many French bedrooms—either adjacent as a separate room or as part of the bedroom itself—can be made into a miniature *boudoir*. There's no need for this space to be overly fancy or forced. You aren't required to buy antiques and Oriental rugs. Any kind of furniture and décor works, so long as it fulfills the function of the room. It should be your personal retreat and reflect your personal taste. It should be a place of escape and sanctuary. Like every other room in a French home, the *function* of the room is what matters. Not the décor.

Recently, inspired by my memories of Jacqueline's *boudoir*, I decided to create my own in my home in New York State. I chose a small room—a former office separated from the master bedroom by pocket doors—and marked it off as my territory. The space was large enough for a small couch, a reading lamp, a vanity table, and a gold-framed mirror. As there is a large closet on one side of the room, this *boudoir* felt less like a ladies' parlor and more like Jacqueline's *boudoir*: a private dressing room.

For me, the fact that the *boudoir* doesn't exist in the

contemporary home is liberating. Extinction gives one all sorts of creative license. You could make a *boudoir* with beanbag chairs or huge pillows scattered over the floor. You could make a *boudoir* that feels like a dressing room on a film set, the vanity full of makeup and stacks of *Vogue* and *Harper's Bazaar* magazines at your feet. Just remember that your *boudoir* is a place of repose. Peace and self-care are much more important than the décor. Be as quirky or as outlandish as you want. Create a room that makes you feel beautiful and special. A place you would share with your friends or—as there are no rules in the modern *boudoir*—lovers. The Marquis de Sade would approve.

French *Boudoir*

- Choose a private space, away from the rest of your family, and fill it with your personal treasures—personal photographs, diaries, love letters, jewelry, favorite books and magazines.

- Make sure there is a comfortable place to lounge. Your *boudoir* should have a couch, a beanbag chair, a daybed, or an overstuffed armchair that will let you sink in and be free to read, think, dream, or listen to music at leisure.

- Be selective. Don't let just anyone into your *boudoir*. This is your secret, special place and friends and family must get your permission to enter. Once you decide that someone should be allowed into your private world, and you sit down together in your

boudoir, understand that the friendship has reached a new level of intimacy.

❋ Hang mirrors. Don't worry about being vain. In the *boudoir*, you should focus on yourself, both the physical and emotional sides of your life. The *boudoir* should reflect you, your taste, and your ideas, in all their various manifestations.

❋ Make your *boudoir* a place to dream while awake. This is where you are free to fantasize, hope, wish, and scheme for all that you want in life.

While the *boudoir* is a place of fantasy, there is something of this quality in every room of a French *maison*. Our home is, as Gaston Bachelard says, our first universe, but it is also the source of our greatest power: the ability to renew our energy each day, to restore our creativity and our passion for life. The rooms in your home reflect the rooms in your mind. In creating your home, you are creating spaces that bring you happiness, well-being, and love. Practical, unglamorous rooms like the *laverie*, and decadent, fantastical ones like the *boudoir*—they are all equally important. Each room of your home is created from your needs, solidifying around you like the protective shell of a snail. How you live in your home defines who you are, what you want, and where you are going. There is nothing small in this journey. As we create our *maison*, we create our lives.

I remember Jacqueline Manon in her *boudoir*. She leaned over her vanity, gazing into the mirror as she tied a head scarf over her hair, folding and knotting it with ease. She looked up, met my gaze in the glass, and smiled. We had an understanding, she and I, a secret, something she had given me. To find joy in the simple

rituals of daily life; to see the deep beauty of an embroidered napkin and the scent of musky incense; to make a private world, a universe of my own—these things, once learned, would never leave me. But most important, Jacqueline showed me how to create the kind of home that would nurture and sustain me through time, a French home that would remind me of her once she was gone.

Postscript

In the end, we should remember that living well in our homes has less to do with the value of our belongings, the usefulness of our gadgets, the beauty of our decorations, or the amount of treasure we have stockpiled. We are happy in our homes because we feel safe and loved there. Our home makes us feel that we have created a private universe that gives purpose and direction to our lives. Without this, we are nomads who have given up the pleasure of acting out our daily lives in a place that knows us intimately. Your home knows your past, it directs you toward your future, and it gives you the comfort of ritual. There is nothing on the planet that knows you and nurtures you like your home. You simply need to give it the tools to take care of you.

Acknowledgments

Merci beaucoup to Lynn Grady and Carrie Thornton at Dey Street for their enthusiasm and editorial savvy. Thank you to my agent Eric Simonoff, and to all the people behind the scenes at WME and HarperCollins who have made the publication of this book possible. I am especially indebted to the Postel-Vinay family for allowing me to write about their private lives, and for introducing me to their French friends, many who have generously opened their homes to me. Thank you to my husband, Hadrien, for showing me the treasures of his culture. I am deeply grateful to have him in my life.

While writing this book, I have drawn on a number

of sources to back up my personal observations: *Nos Maisons* by Beatrice Fontanel, *Le Bonheur de Séduire, L'Art de Réussir* by Nadine de Rothschild, *Histoire de Chambres* by Michelle Perrot, and *Lavoirs: Washhouses of Rural France* by Mireille Roddier.

Glossary

"*à table*": Dinner time! Traditionally called out to announce that dinner is served.

à la mode: In style

apéro / apéritif: A casual gathering in which friends/family share a drink and snacks

apéro-dînatoire: An *apéro* that goes late, involves easy finger food, and replaces dinner

archives: Files in which you organize family papers

armoires: Large wooden storage cabinets

arrondissement: Neighborhood division or quarter in Paris

baignoire ambulante: Movable bath

bain-marie: Double boiler

bourdaloue: A porcelain piss pot shaped like a gravy boat

bandes dessinées: Popular Belgian and French comics

bête noire: Something that annoys

beurrier: A butter dish with a top

bibliothèque: Home library

bidet: A fountain used to wash your nether regions. Can be a separate porcelain stool in the bathroom, or can be combined with the toilet.

boeuf bourguignon: Traditional French beef stew from Burgundy

bon appétit: Phrase said at the beginning of a meal that wishes everyone a good meal. Signals that everyone may begin eating.

bon goût: Good taste

boudoir: A traditional female sitting room (as opposed to the *fumoir*)

bouillabaisse: Traditional French Provençal fish stew from Marseille

bouquet parfumé: Scented or perfumed sticks

boutis: Provençal quilt, or the art of stuffing a quilt

brocantes / puces: street markets and flea markets

bureau: Office

cabinet de curiosité: Curiosity cabinet, a place to display exotic collectibles

café au lait: Coffee with milk

calèche: A carriage

Camargue: A region in the south of France between Nîmes and Montpellier

carré: Square

cave: Cellar

chambre: Bedroom

charcuterie: Sliced meats

coffre: A large wooden chest, often for clothes, but also for

silverware or other precious objects

confiture: Jam or preserves with fruit

coq au vin: Traditional French chicken stew with red wine

cornichon: Small French pickles

couette: Comforter

cuisine: Kitchen

derrière: Behind or bottom

détachants: Stain removers

digestif: A liquor taken at the end of the meal to aid in digestion

dressing: A walk-in closet used for dressing

eau de toilette: Less potent perfume

eau-de-vie: Light, colorless fruit brandy

École Militaire: A military academy in the 7th *arrondissement*

en masse: In a group

entrée (meal): First course

entrée (room): Entryway

escargot: Snail. Most often served with a garlic, butter, and parsley sauce.

étagères à livres: Bookshelves

faux ami: False friend

figuier: Fig tree

fleur de sel: High-quality salt that forms as a thin crust on the surface of seawater

fondant au chocolat: Molten chocolate cake

foyer: Hearth

frigo: Refrigerator

fumoir: A traditional male sitting room (as opposed to the *boudoir*)

garçonnière: Bachelor pad

garde-manger: Pantry

garde-robe: Wardrobe or big closet

gourmand: Someone who loves to eat

goûter: After-school snack eaten by French school children

haricots verts: Green beans

herbes de Provence: Herb mix of the Provence region of the south of France

hygge: Danish concept meaning "coziness"

ikebana: Japanese art of flower arrangement

La Cornue: Heavy, high-quality French stove

laverie: Laundry room

Les Invalides: Monument in the 7th *arrondissement* where Napoleon is buried

lit clos: Old-fashioned bed consisting of wooden posts and enclosed with drapery

maison: Home

midi: Noon

mise en place: To put in place, or everything in its place

monsieur/madame: Mr./ Ms. or Mrs.

nabe: Japanese stew

pain au chocolat: Chocolate croissant

parfait jar: Traditional canning jar

patrimoine: French cultural heritage passed down in French families and in French society

plan de table: Seating arrangement

plat principal: Main dish

poêle: Gas, electric, or wood-burning stove

Provençal: From the region of Provence in the south of France

quelle horreur!: "How terrible!"

raison d'être: Reason for being

ratatouille: Traditional French tomato-based vegetable dish from Provence

repas gastronomique: A large meal involving traditional French food, which is most often taken with family and friends

salle à manger: Dining room

salle de bain: Bathroom, where one bathes

salon: Living room

sèche-linge: clothes dryer

serviettes: Napkins, tea towels, bath towels

souillarde: Scullery

tagine: Cone-shaped earthenware casserole and also the Maghrebi dish cooked using the tagine

tartare (steak tartare): Fresh raw hamburger eaten cold with capers, Worcestershire sauce, pickles, and mustard

tartines: Open-faced toasted sandwiches made with French baguettes

toilette: Separate room with a toilet

vaisselier: A hutch or shelf for dishes

About the Author

Danielle Postel-Vinay lives in New York City and the Hudson River Valley of New York with her children and her Parisian husband.